PORT OF LONDON
THROUGH TIME
Geoff Lunn

AMBERLEY PUBLISHING

The Port of London's history can be traced back over many centuries. Among the most significant events in that time were the creation of a series of enclosed docks and, more recently, the closure of the more upriver dock systems along with many riverside wharves. Cloth-capped dockworkers, whose lives depended upon the river and its ships, are now a memory of the past as new leisure and residential developments emerge along the quaysides. Although London's old docks and wharves had their own identities, there was much similarity between them, and so this book affords much attention to the wide variety of shipping that used their facilities over the years and, indeed, the modern vessels that come into the port today.

First published 2011

Amberley Publishing
The Hill, Stroud
Gloucestershire, GL5 4EP

www.amberley-books.com

Copyright © Geoff Lunn, 2011

The right of Geoff Lunn to be identified as the
Author of this work has been asserted in accordance
with the Copyrights, Designs and Patents Act 1988.

ISBN 978 1 4456 0254 7

British Library Cataloguing in Publication Data.
A catalogue record for this book is available from
the British Library.

Typeset in 9.5pt on 12pt Celeste.
Typesetting by Amberley Publishing.
Printed in the UK.

Introduction

London was a port even before it became a great city and the capital of England. In pre-Roman times the inhabitants of south-eastern Britain traded with Continental Europe mainly through south coast ports, and the shortest route to bring goods from the rich agricultural areas of East Anglia to these ports was by way of a ford located just downriver from where London Bridge now stands. Soon, many traders were meeting regularly at the ford and gradually a settlement was established. When the Romans came, they quickly expanded British exports to the Continent, and Londinium, as London was then known, grew rapidly in size and importance.

Over the following centuries the development of the Port of London was a story of enterprise and much high adventure. Shipowners and merchants took considerable risks in their quests for trade, while creating several early maritime companies, including, in the year 1600, the East India Company that would go on to forge a long-standing association between the Port of London and India.

In those days, the Thames at London was permanently congested with ships lying at their moorings, discharging cargoes into small lighters in which, due to the inadequate number of wharves, they would remain open to the elements and the devious hands of river thieves for weeks at a time. Records show that in the Upper Pool as many as 1,775 vessels were allowed to moor simultaneously in a space meant for just 545. The need for more dedicated wharves and enclosed dock systems was paramount, yet, by the end of the seventeenth century only two new docks had been built, at Blackwall and at Rotherhithe, and, moreover, their prime purpose was the repair of ships.

In 1799, the English Parliament passed a Bill, promoted by the West India Merchants and the Corporation of London, for the construction of a pair of enclosed commercial docks, heralding an important period encompassing much of the nineteenth century, during which a series

of dock systems was created between Tower Bridge and Tilbury. In their early years the docks were privately owned, but in 1909 they were taken over by the newly formed Port of London Authority at a cost of £32 million. Even today, the ninety-five miles of the tidal Thames, between Teddington and the Nore, is controlled by the PLA, whose responsibilities include the safe navigation of this stretch of river, but no longer ship handling.

By the end of the 1930s, London had become the world's busiest port, its docks covering a water area of some 720 acres. Ships arrived from all parts of the globe, bringing in cargoes of every conceivable description: from wool to wine, tobacco to timber, meats and dairy produce. During the 1950s, as Britain moved from austerity to post-war boom, the number of vessel calls reached even greater heights, peaking in 1961 when almost five million tonnes of cargo was handled.

Yet, within a decade, the picture had completely changed due to the arrival of a revolutionary method of cargo transportation: the container. With added progress in roll-on/roll-off technology, the conventional freighter was suddenly defunct as ships became much larger and more specialised. Unable to cope with these new breeds of ships, London's docks slowly but surely closed. Some docks were filled in; other water areas have been retained, but vastly altered, as residential property, office blocks, retail centres and leisure facilities have sprung up where ships once unloaded their wares. Even the wharves within the Pool of London have similarly been redeveloped, changing the face of London's river for ever. Only the docks at Tilbury, with their expansive and deeper waters, have remained in commercial use, and it is in neighbouring Gravesend Reach that we begin our upriver journey to the City of London, a journey that tells the dramatic story of the Port of London.

The Wedding Cake
Affectionately dubbed the 'Wedding Cake' because of its distinctive design, the Port of London Authority's headquarters at Trinity Square in the City of London opened in 1922. This fine building was sold to an insurance firm in June 1972, being too large and expensive for the Authority's diminishing staff numbers as the docks began to close down.

Swanning Along at Gravesend
The local swans can relax during a lull in river traffic at Gravesend Reach, the point where our journey upriver begins.

chapter 1

Gravesend to Gallions

Located approximately 41 km (26 miles) downriver from London, Gravesend has always been a superb vantage point for ship spotters. The north Kent town became a resort in Victorian times as visitors arrived by excursion steamers and flocked to its attractive riverside gardens. The Town Pier was erected in 1834 and for many years served as Gravesend's landing point for a ferry to Tilbury. Before the days of the Dartford Road Tunnel, built in 1963, vehicles, as well as foot passengers, would be conveyed across the 923 metres of Thames waters by ferry. The first passenger steam ferries came into service in 1855, while the car ferries operated from the 1920s, but nowadays only a small single craft maintains the route. Yet Gravesend keeps its close connections with the tidal Thames, the PLA having moved its headquarters from the City of London to the London River House, adjacent to the Royal Terrace Pier from where a team of twelve river pilots join incoming vessels on their journeys upriver as far as London Bridge.

The town of Tilbury is of historic importance as it was on the marshland site of its docks that Queen Elizabeth I made her greatest speech as she inspected the Earl of Leicester's troops as they prepared to set sail to face the Spanish Armada in 1588. As dock construction in the nineteenth century continued to move downstream to meet the growing number of large ocean-going ships, an Act of Parliament was passed in 1882 to permit the East & West India Docks Company to build the docks as direct competition with the Royal Albert Dock, previously the farthest downriver dock and owned by a rival company. Tilbury Docks received their first vessel, the Glen Line ship *Glenfruin,* on 17 April 1886.

When upriver docks were steadily shutting down in the 1960s, the Port of London Authority further extended Tilbury Docks, whose new larger basins proved their worth in 1970 when the first ships of the new container era began regular sailings from the Thames. A year earlier, a riverside grain terminal had been opened in adjacent Northfleet Hope and from then on continuous riverside development outside the docks saw the creation and later expansion of a deepwater container terminal in the same stretch of river and the construction of a car import facility opposite Gravesend.

Since their privatisation in 1992, the docks have gone from strength to strength with the creation of further specialised berths, and the complex is successfully leading London through the twenty-first century as one of Britain's major ports, even though its upriver docks have long been condemned to history.

Upstream from Tilbury, the River Thames flows through Long Reach, passing under the impressive QEII Bridge that complements two Dartford Toll Tunnels, close to which short-sea roll-on/roll-off berths are constantly in action. Further on, as the river swings past Barking, it enters Gallions Reach.

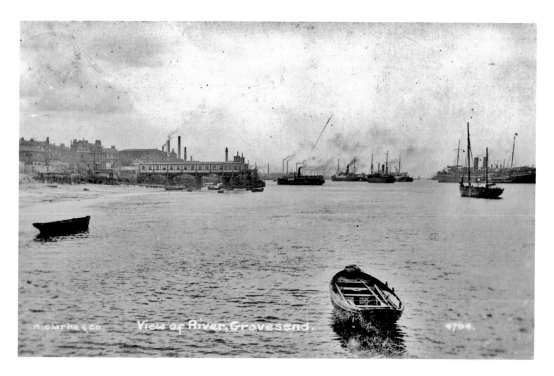

Little Change

Gravesend's waterfront at dusk, looking upstream towards the Royal Terrace Pier during the early years of the twentieth century. Note the abundance of shipping, including a two-funnelled passenger liner and the ferry approaching Gravesend. A similar view a hundred years on reveals the addition of riverside apartments, but the pier and riverfront appear virtually unchanged.

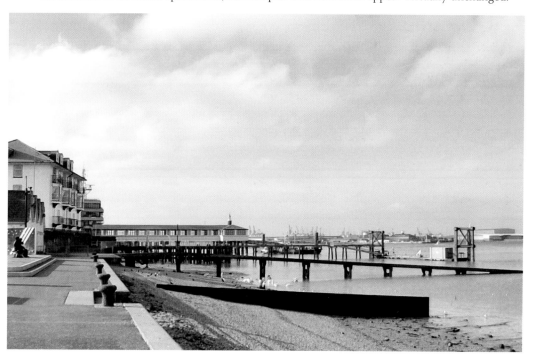

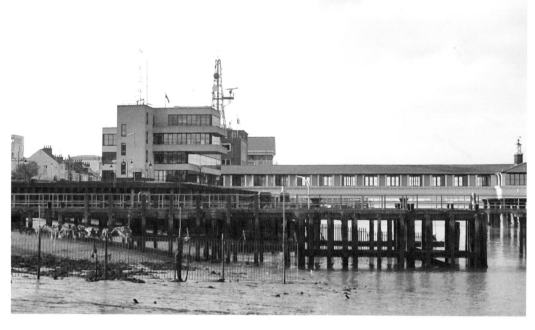

A Historic Pier

Today, the PLA's Port Control, Thames Navigation and headquarters are all located at Gravesend, adjacent to the Royal Terrace Pier. The pier dates from 1844 but a glass-fibre structure has replaced the original Doric columns. It has long been the base for Gravesend's river pilots. Note the tugs moored off the pier-end, even in this early image.

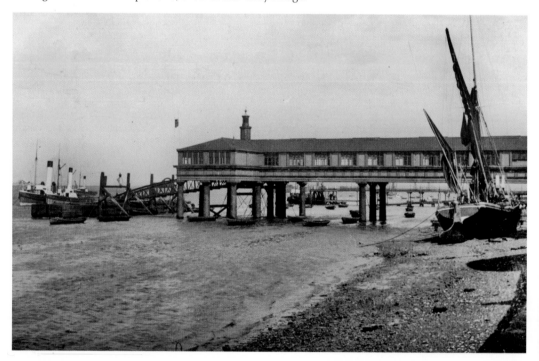

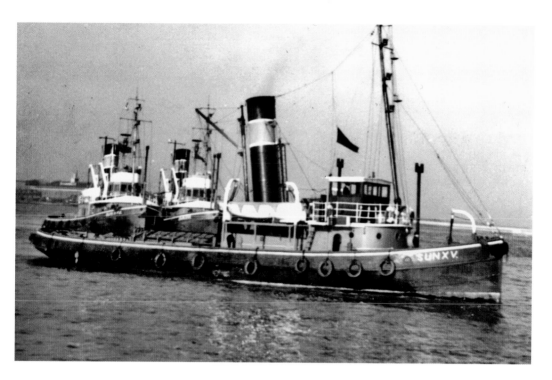

From Steam to Diesel on the Thames

The advancement in size, power and manoeuvrability of Thames tugs over the years has been quite remarkable. Yet London's ship towage fleet still gathers off Gravesend, just as it did more than a half a century ago. *Sun XV* of 1925, owned by W. H. J. Alexander Ltd, measured 183 gross registered tons (grt), whilst in comparison, and several company takeovers later, the twenty-first-century tug *Svitzer Victory* (ex-*Gurrong*), owned by the Danish concern Svitzer and built in Australia, measures 495 grt and is 33 metres long.

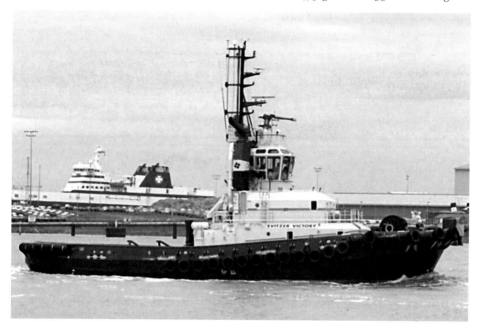

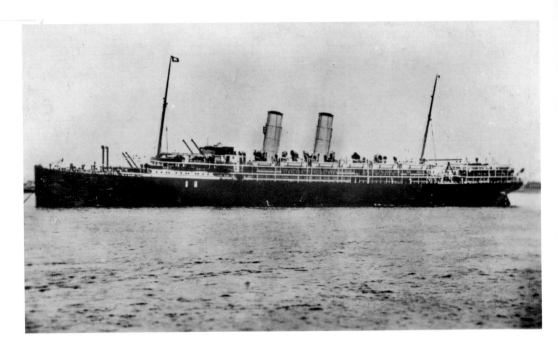

Gravesend Reach Moorings

In the early 1900s, before the establishment of a riverside passenger terminal at Tilbury, handsome liners such as Orient Line's *Orsova*, 12,026 grt, would moor off Gravesend to discharge and take on passengers by tender. Half a century later and contrasting vastly in shape and design, the Lighter Aboard Ship (LASH) *Doctor Lykes*, 1972/21,667 grt, lies in Gravesend Reach. With her sisters, *Almeria Lykes* and *Tillie Lykes*, she maintained a regular service from US Gulf ports for a number of years.

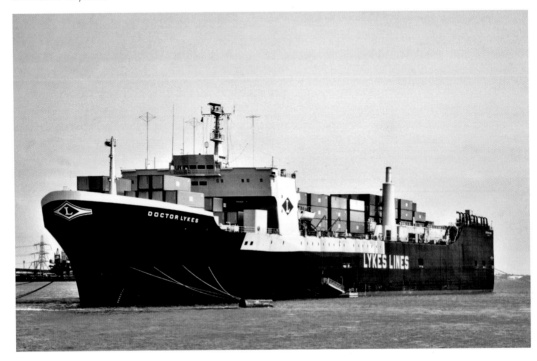

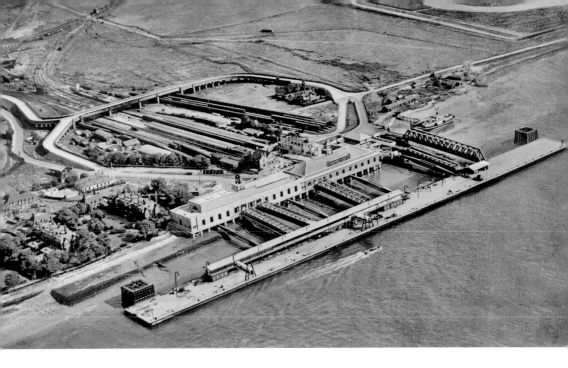

Gateway to a New World

Since its opening by Prime Minister Ramsay MacDonald in May 1930, Tilbury Landing Stage has remained London's premier passenger ship terminal. Measuring 348 metres long and constructed on sixty-three pontoons, it was the departure point for many thousands of Ten Pound Poms bound for Australia after the Second World War. Refurbished in 1989 to meet the new demands of cruising, it is now known as the London Cruise Terminal.

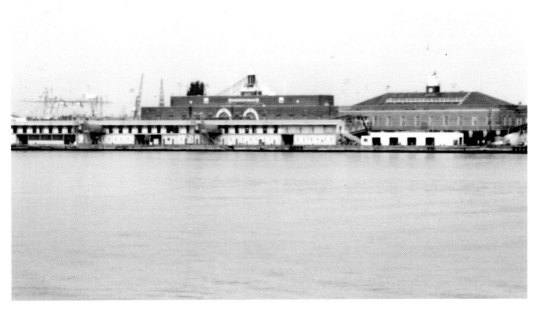

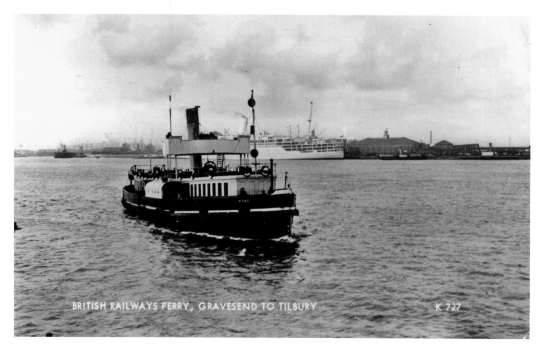

BRITISH RAILWAYS FERRY, GRAVESEND TO TILBURY K 727

Long-Running Ferries

Gravesend and Tilbury have been linked by ferry since the sixteenth century, although the first service operated by a railway company began in 1862. *Rose*, 1901/259 grt (note the P&O *Strath* liner at Tilbury Landing Stage behind), was the first of a quartet of passenger steam ferries built in the early 1900s. *Gertrude* was broken up, but *Catherine, Edith* and *Rose* herself maintained the crossing until 1961, by which time three new diesel craft of the same names had been completed. The second *Catherine* is taking centre stage at Tilbury, flanked by the Union Castle liner *Rhodesia Castle* (left) and short-sea passenger ship *Prinsessan Christina*.

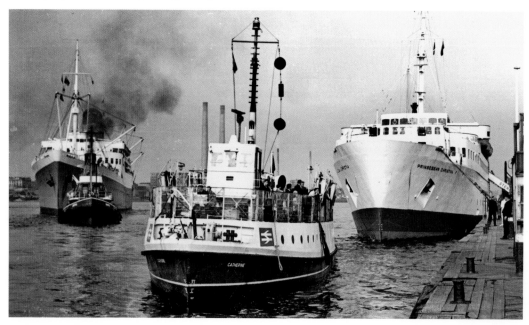

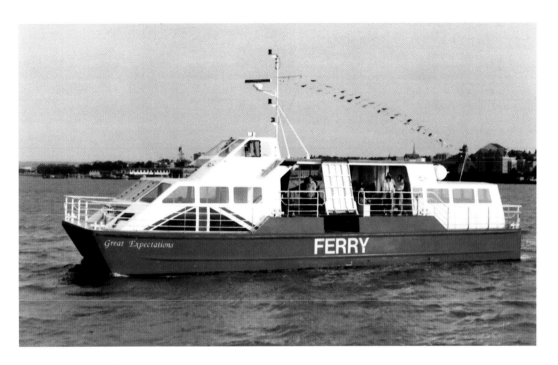

Recent Ferryboats

British Railways ceased control of the Gravesend–Tilbury service in 1984 and subsequent years have been full of financial turbulence. White Horse Ferries completed their catamaran *Great Expectations CD* on a Gravesend slipway in 1991, but she was transferred to Southampton after four years. Since then the small vessel *Duchess M*, which appears to be competing for position with a modern Thames tug, has done her best to keep the service going. She is privately owned by the Lower Thames & Medway Passenger Boat Company.

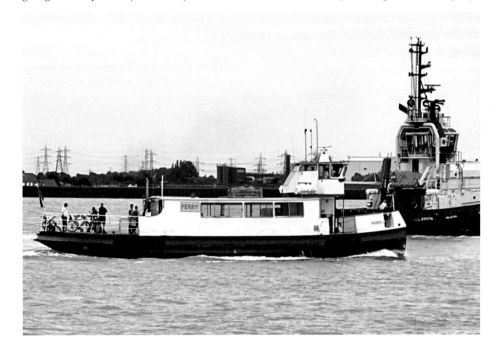

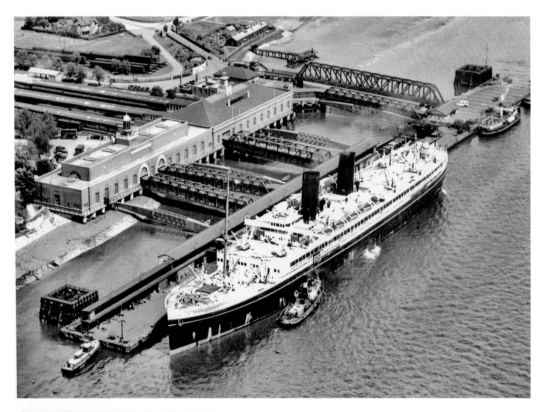

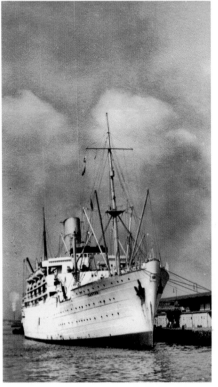

Black and White
The 1923-built P&O liner *Mooltan,* 21,039 grt, berthed at Tilbury landing Stage, having sailed in from Australia. With her sister *Maloja*, she was employed as an austere post-war migrant ship before being broken up in 1953. All P&O passenger liners were later painted white, including the 16,033 grt *Canton* that served the company's other main route to the Far East.

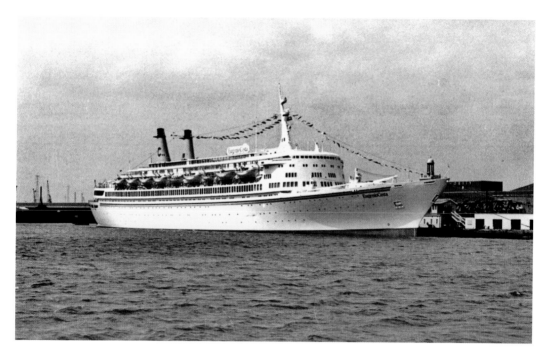

Liner to Cruiseship

Eugenio Costa, 32,753 grt, built in 1966 for Costa Line's South American passenger liner service and converted for cruising in the late seventies, made a rare visit to the London Cruise Terminal in 1989. She was broken up at Alang in 2005. During the 1990s, the purpose-built cruise ship *Royal Princess*, 1984/44,348 grt, the first such vessel to feature balconies, made a series of cruises from the Thames. She later became P&O's *Artemis* before recently being sold to Germany.

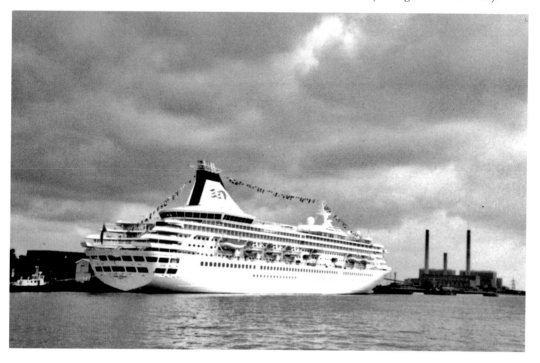

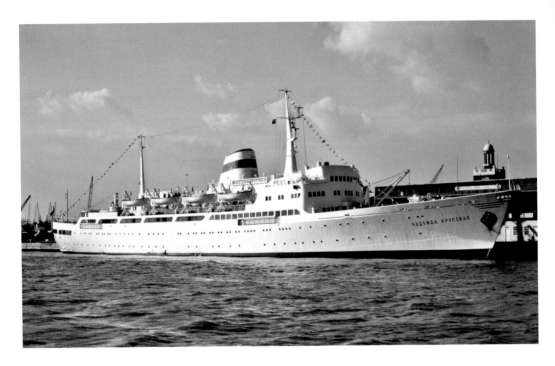

From Russia with Passengers

A member of the *Mikhail Kalinin* class of nineteen small passenger ships built for the former USSR, *Nadeshda Krupskaya*, 1963/5,261 grt, operated between Tilbury Landing Stage and Leningrad (now St Petersburg) for several years, accommodating 300 passengers. Larger Soviet-owned *Belorussiya* class ships, constructed as Black Sea cruise ferries, were converted into cruise ships and of the five *Kareliya* (ex-*Leonid Breshnev*), *Azerbaydhzan* and occasionally *Belorussiya* herself were employed on summer season cruises out of Tilbury.

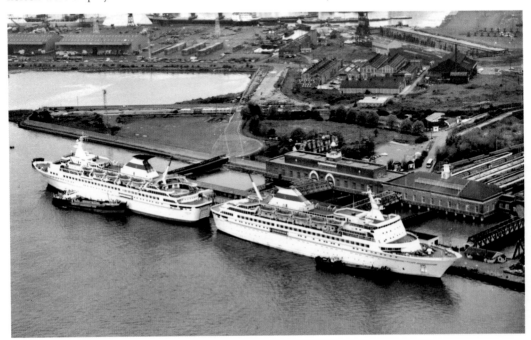

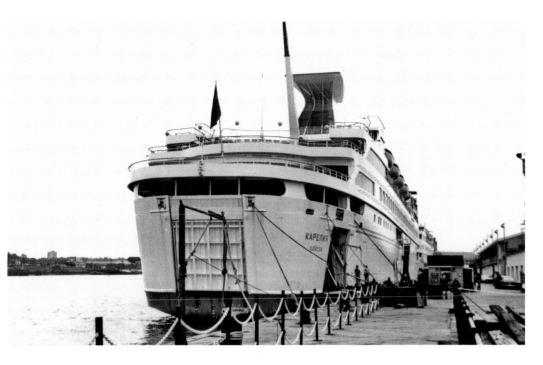

Former Soviet Sisters

Kareliya was undoubtedly one of the most popular cruise ships to operate from the Port of London. Built in 1976, the 15,065-grt vessel offered budget-priced voyages under charter to British-based CTC Cruise Lines from 1981 to 1994. Note the stern door, a legacy from her early cruise ferry days. In 2004, one of her original sister ships, *Gruziya*, arrived in the guise of the 15,403-grt *Van Gogh*, cruising for the travel company Travelscope.

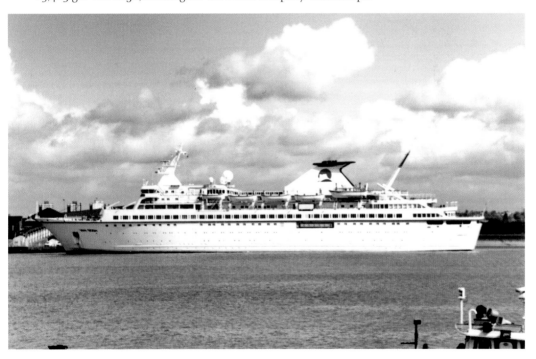

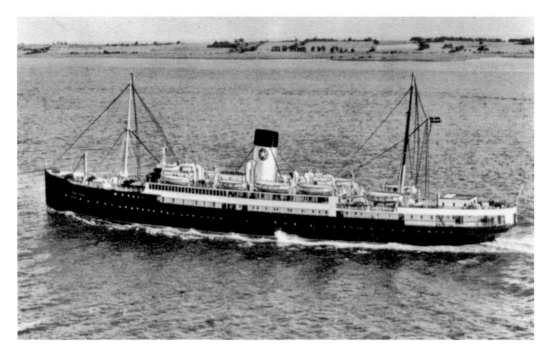

Swedish Connections

Passenger-carrying ships of Swedish Lloyd linked Tilbury with Gothenburg for almost five decades. The trusty steamships *Suecia*, 4,661 grt, and *Britannia*, 4,653 grt, both entered the service in 1929. In 1966, they were sold to Hellenic Mediterranean Lines on being replaced by the new larger *Saga* and her sister *Svea*, 7,883 grt, which at the time was owned by Rederi Ab Svea but was later to join the Swedish Lloyd fleet.

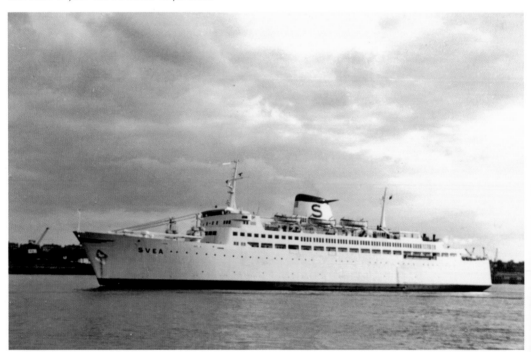

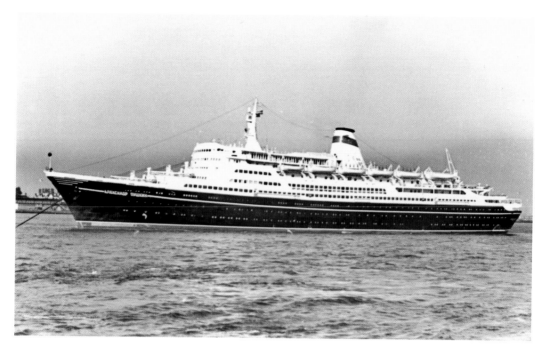

The Wanderer Returns

Delivered in 1965 to the former Soviet Merchant Marine, *Alexandr Pushkin* maintained a liner service between Leningrad (St Petersburg) and Montreal, calling at Tilbury Landing Stage. Subsequent cruising schedules still saw her in the Thames until a new career as the *Marco Polo* with newly formed Orient Lines took her far and wide, including the Antarctic. Now she is back where she began, retaining her second name but cruising year-round from the London Cruise Terminal under charter to Dartford-based Cruise & Maritime.

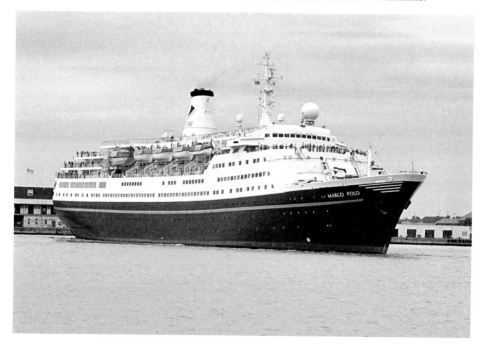

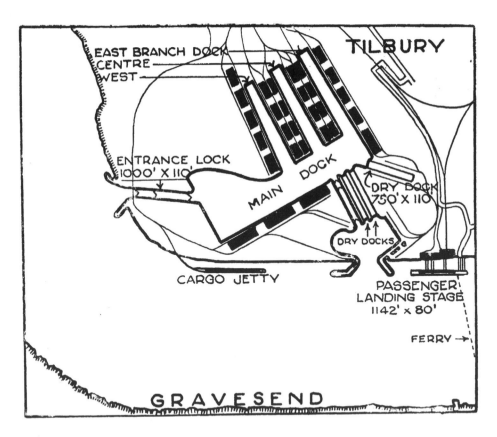

Tilbury Docks

As shown by this map, the Tilbury Docks system comprised a large main dock off which ran three parallel branch docks. During the 1920s, a 229-metre-long third dry dock was added in the south-eastern corner, a riverside cargo jetty was constructed outside the docks, whilst the whole system was enlarged from 74 to 90 acres. In the later view below, the P&O liner *Chusan*, 1950/24,062 grt, is berthed in the westerly corner of the main dock with an Orient liner behind. The docks' main entrance can clearly be seen in the background.

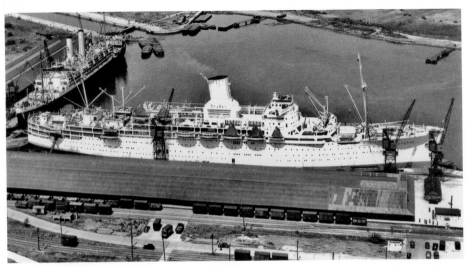

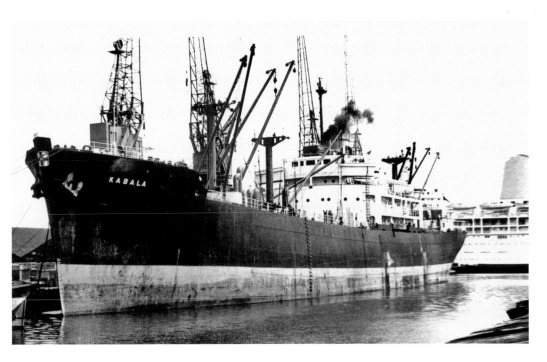

West African Links

Strong commercial links were forged over the years between Tilbury Docks and ports of West Africa. Employed on this route, Elder Dempster Line's *Kabala*, 1958/5,445 grt, maintained a regular service until being sold to Greek owners in 1973, whilst *Kano Palm*, 8,723 grt and also completed in 1958, plied the route for Palm Line until 1979.

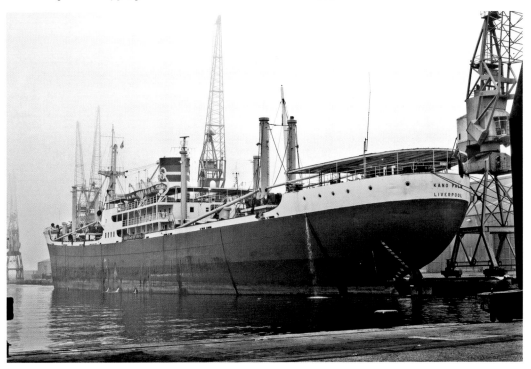

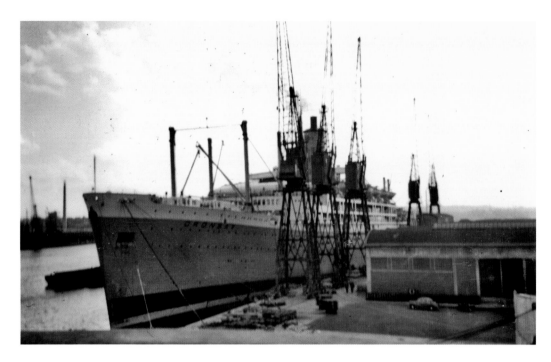

Tilbury's Entrance

Oronsay, 1951/27,632 grt, owned by the Orient Line, at her Tilbury berth during the 1960s. Her predecessor, built in 1925, held the honour of being the first ship to pass through the docks system's 304.8-metre-long western entrance lock on 29 September 1929. The lock, that replaced the docks' original tidal basin leading from Gravesend Reach, remains their only point of entry to this day and has handled a variety of vessels, including Palm Line's *Africa Palm*, 1972/10,008 grt.

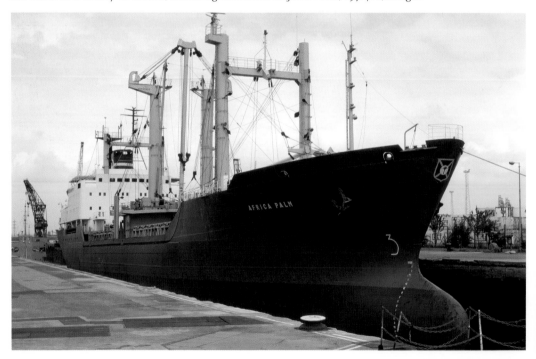

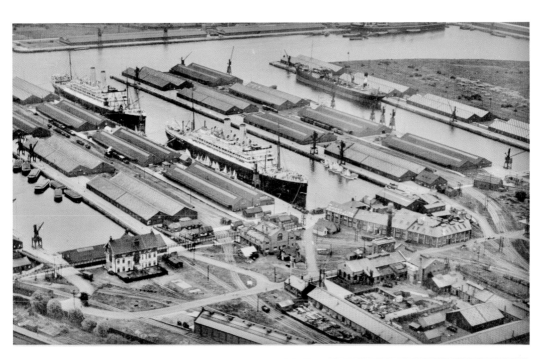

Orient Liners in Tilbury Docks

Two Orient Line passenger ships – probably *Orontes* and *Otranto* – at their berths in Tilbury's centre parallel dock. Passenger-carrying liners in those days would also carry considerable amounts of cargo that would take up to a week to load, as shown on this broker's card of 1958.

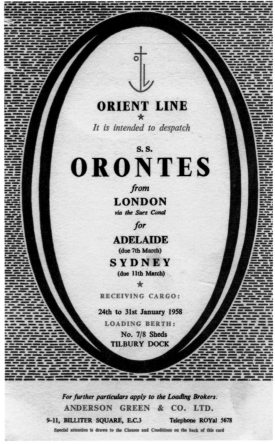

ORIENT LINE
★
It is intended to despatch

s.s.
ORONTES
from
LONDON
via the Suez Canal
for
ADELAIDE
(due 7th March)
SYDNEY
(due 11th March)
★
RECEIVING CARGO:

24th to 31st January 1958
LOADING BERTH:
No. 7/8 Sheds
TILBURY DOCK

For further particulars apply to the Loading Brokers:
ANDERSON GREEN & CO. LTD.
9–11, BILLITER SQUARE, E.C.3 Telephone ROYal 5678
Special attention is drawn to the Clauses and Conditions on the back of this card

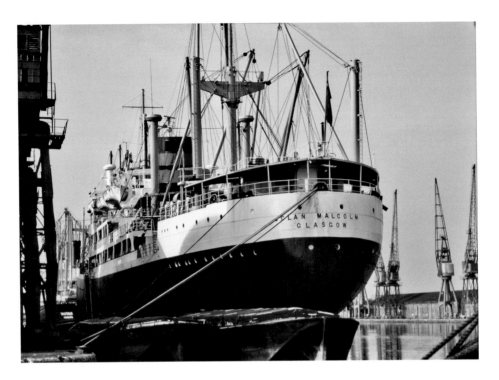

Regulars and Strangers

Cargo vessels owned by Clan Line were a familiar sight at Tilbury, even from the early days of the docks. *Clan Malcolm*, 7,356 grt, joined the fleet in 1957, staying until 1979 when she was sold and renamed *Trinity Fair*. On occasions, Tilbury would host less familiar vessels, such as the Greek-owned *Hellenic Glory*, 1956/7,510 grt, that appears to be in need of a lick of paint.

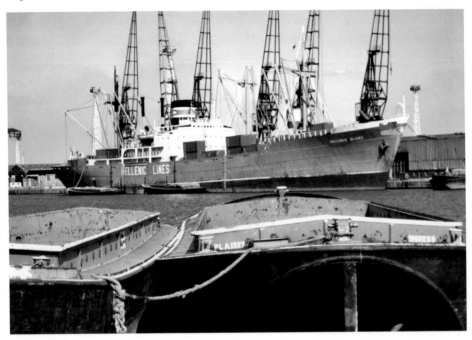

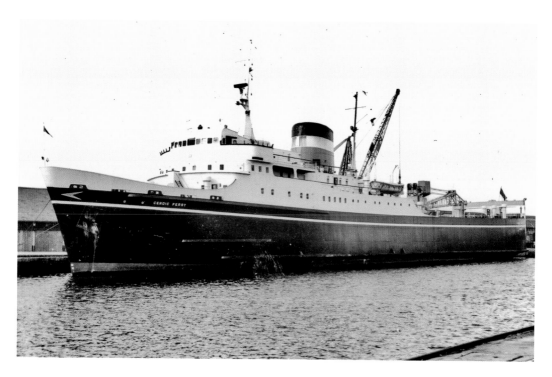

Ro-Ro Revolution

One of the first commercial roll-on/roll-off vessels to operate from the UK, *Cerdic Ferry*, 1961/2,563 grt, embarked on a regular Tilbury–Rotterdam sevice for the Atlantic Steam Navigation Company in November 1961. Her identical sister, *Doric Ferry*, linked Tilbury with Antwerp and each ship could accommodate fifty-five passengers. Designed to carry lorries, their vehicle lanes had sufficient headroom to fit in a double-decker bus. As ro-ro ships developed in size and technology, a weekly service from Tilbury to Gdynia was undertaken by the Polish ro-ro vessel *Inowroclaw*, 1980/7,510 grt. Although accommodating just twelve passengers, she would transport containers, cars and even helicopters.

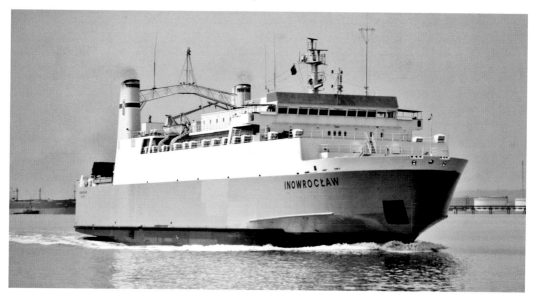

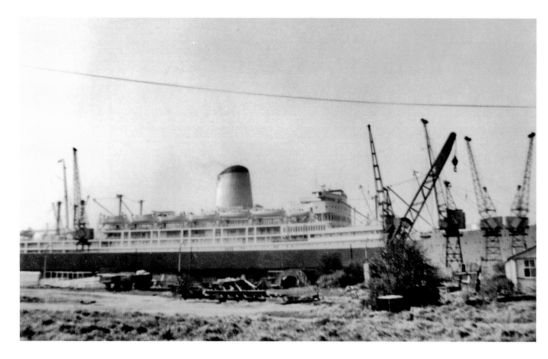

Tilbury's Biggest

In the heyday of passenger liner travel, P&O's *Arcadia*, 1954/29,871 grt, her stylish upperworks displayed above No. 31 Shed, was the largest ship to berth in Tilbury's enclosed docks. Now this accolade has passed to a class of Italian *Grande* ro-ro ships, owned by the Grimaldi group and sailing to West Africa and South America. Each of these vessels carries cars, trucks and containers. An example of this class, *Grande Nigeria*, 2003/56,738 grt, passes Gravesend en route for the docks.

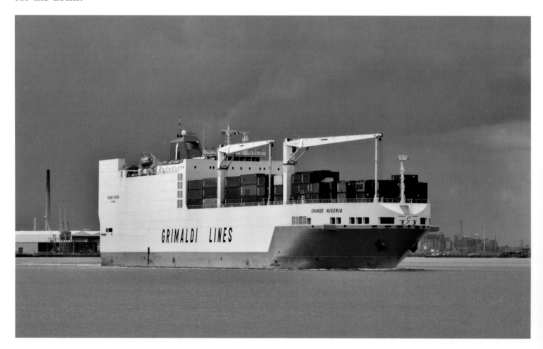

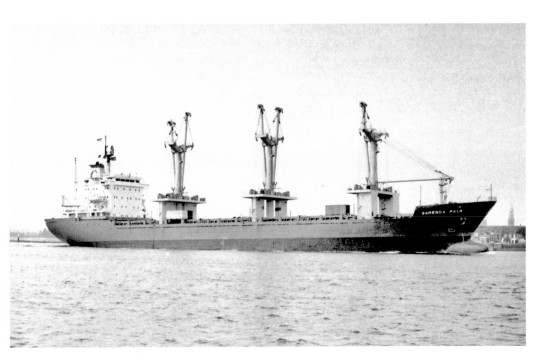

Cargo Ship Design

With the coming of the container and ro-ro age, cargo ship design became increasingly sophisticated. *Bamenda Palm,* 1979/11,223 grt, was one of the last vessels operated by Palm Line. Described as a 'multi-purpose ship', she was still essentially a conventional cargo ship and by 1984 was no longer calling at Tilbury, having been chartered out to Brasil. The 20,154-grt *Ostrand* and her two sisters *Obbola* and *Ortviken*, however, were purpose-built in 1996 to serve Tilbury's No. 44 Berth Interforest Terminal. Built for SCA Transforest to carry Swedish paper products, the 171-metre-long vessels need no cranes or vehicles, transporting their loads on 165 wheel-less cassettes.

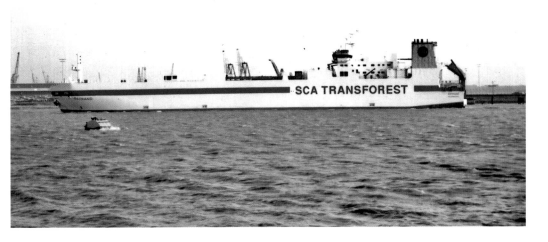

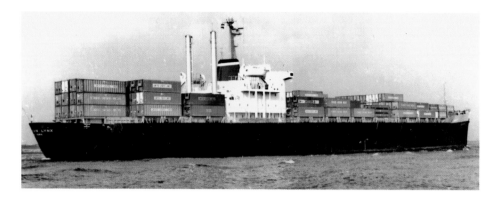

Re-Shaping for the Future

In June 1968, the first of seven new *Lancer*-class container ships owned by the United States Lines discharged her complement of containers at No. 40 Berth, Tilbury Docks, in just thirteen hours, thus confirming that this method of conveying cargoes was undoubtedly the way forward. *American Lynx*, 1968/18,867 grt, was part of that new transatlantic service which operated until 1971. Tilbury's dock system today has been re-shaped to meet the many changes in cargo-carrying methods. In 1992, the docks were privatised following a management buyout and by the beginning of 1996 Forth Ports plc had successfully purchased them. Now, with thirty-four modern terminals handling a wide variety of commodities, the docks are officially known as the Port of Tilbury.

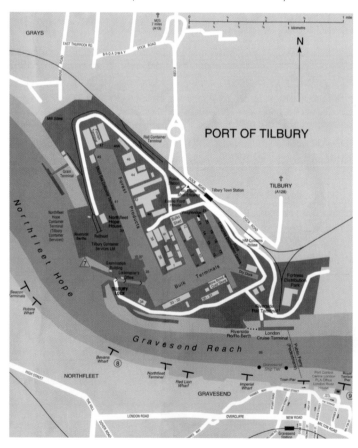

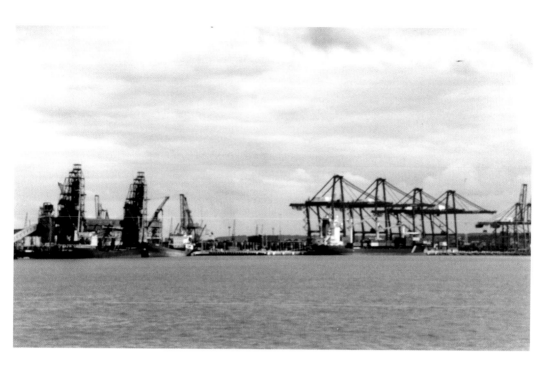

Grain and Containers

The year 1969 saw significant changes to the western perimeter of Tilbury Docks with the completion of a grain terminal, on the left above, in Northfleet Hope and the adaption of Nos 39 and 41 Berths in the enclosed docks for handling container ships. Initially operated by Overseas Containers Ltd (OCL), the container facility was extended externally into Northfleet Hope and today a 600-metre riverside berth can handle two large container vessels simultaneously. The terminal is now managed and operated by Tilbury Container Services. OCL's *Jervis Bay*, 1970/26,876 grt, was the first ship to load at the container terminal following its official opening in 1970.

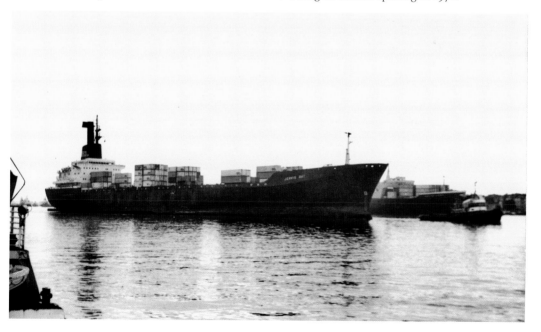

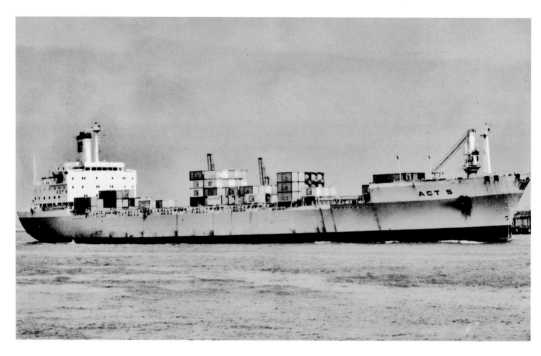

The Acts Get Bigger

During the Tilbury container terminal's early years, ships of Associated Container Transportation (ACT) partnered those of OCL on routes to Australia. The 24,212-grt *Act 5* was delivered in 1972 and carried almost 1,300 TEU (twenty-foot equivalent units). Two decades on, container ships as large as the *Act 8*, with more than twice the box capacity, were berthing at Northfleet Hope.

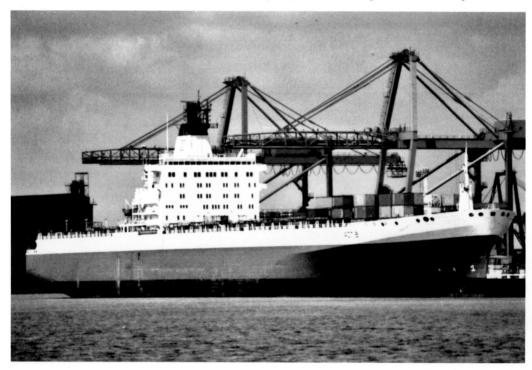

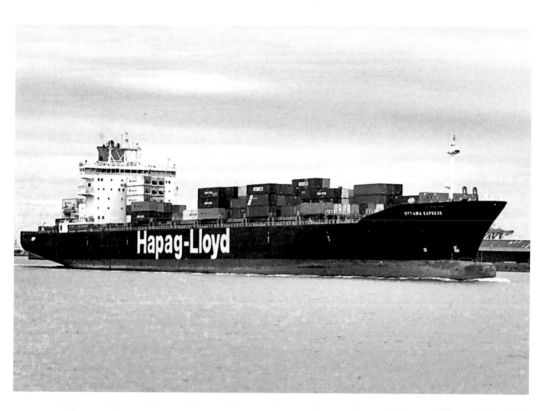

... And So Do the Germans

Ottawa Express, 1998/39,174 grt, operated by Hapag Lloyd, long-term clients of Tilbury Container Services, passes Gravesend outward bound for Bremerhaven and beyond. Her container capacity is 2,800 TEU compared with 5,900 carried by the huge *Rio Bravo*, 2009/73,899 grt, owned by the Hamburg-Sud group, pictured arriving with the assistance of two tugs. She is the fifth of six identical sisters sailing between European ports and South America and is one of the largest ships ever to berth upriver from Gravesend.

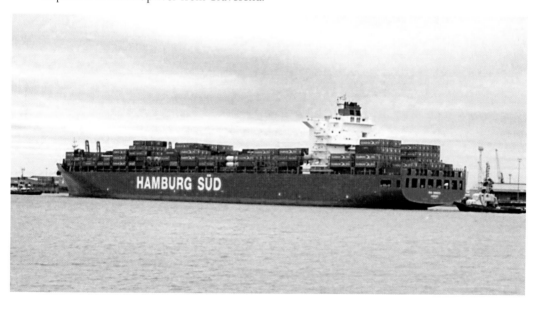

From Tankers to Cars

A Port Line cargo ship passes a methane gas tanker berthed at Tilbury's tanker cleaning jetty in the 1960s. Now the jetty and Tilbury Docks' original tidal basin, which was filled in, have been replaced by a car terminal from where UECC (United European Car Carriers) launched a service to Turkey in 2002. The 1983-built *Nobleza* is typical of the modern-day car carrier whose design can best be described as 'functional'.

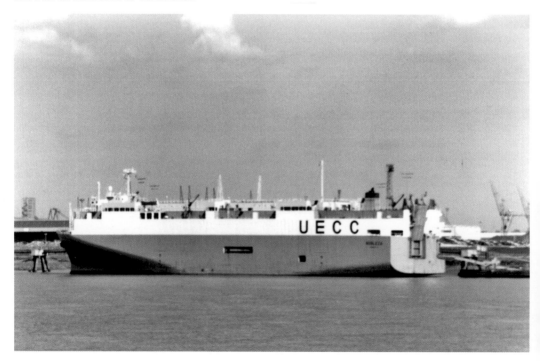

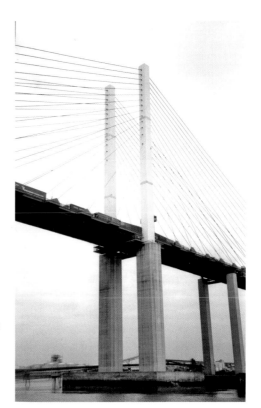

Purfleet and Dartford Terminals
In the shadows of the QEII Bridge that carries
the M25 motorway from Essex to Kent, short-
sea ro-ro berths have grown up into a major
port facility since their birth in 1985. Terminals
have developed at Purfleet and Dartford and
in their earlier years the Purfleet berths hosted
the United Baltic Company's *Baltic Progress*,
1974/4,668 grt, that ran a weekly service to
Rotterdam and Helsinki.

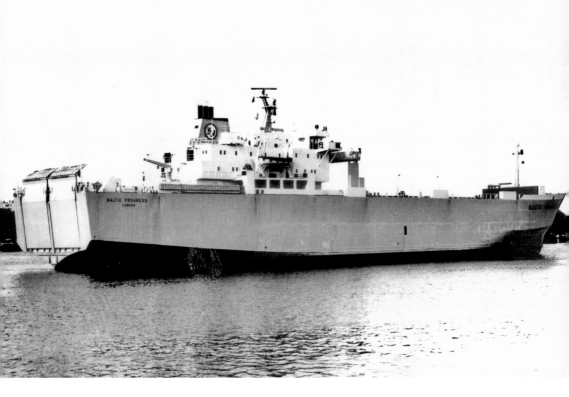

Dart Line and Cobelfret

Thames Europort was inaugurated in 1994 at the former Dartford International Ferry Terminal. Ro-ro vessels of the newly formed Dart Line soon moved in, the expanding fleet, including *Dart 3*, 1984/9,088 grt, sailing daily to the ports of Zeebrugge and Vlissingen. The Belgian concern Cobelfret NV was already operating its own vessels and chartered tonnage from the Purfleet terminal to the near-Continent and in 2006 acquired Dart Line together with the Thames Europort berths. The 23,987-grt *Victorine*, delivered in 2000, is one of the largest fleet members, with room for 446 cars.

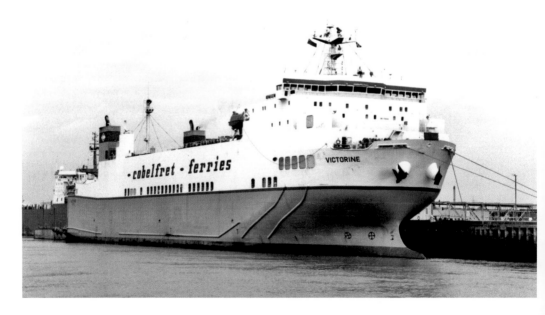

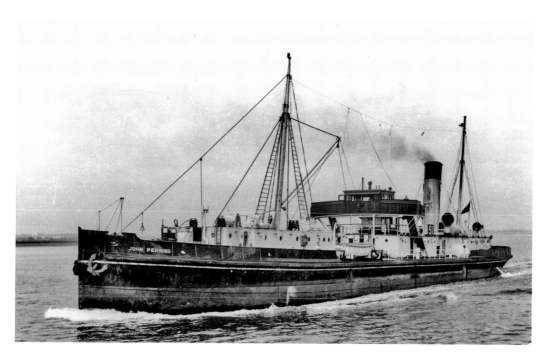

London's Wastes

For 111 years, Thames sludge boats, affectionately known as the 'Bovril Boats', transported London's sewage down the river for discharging in the North Sea. In 1999, EC regulations decreed that this dumping of waste should cease, and since then the sewage has been burned in incinerators at Beckton and Cross Ness. An example of these familiar vessels was the *John Perring*, built in 1926 for London County Council. General waste, however, continues to be conveyed downstream in compacted form, as demonstrated by this small Cory Environment motor tug as she hauls her lighters.

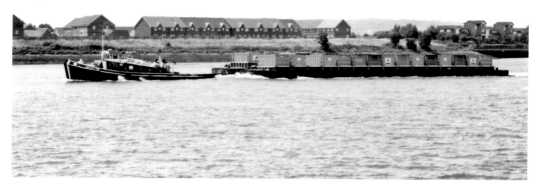

Royal Docks to Rotherhithe

From Gallions Reach, the Thames straightens as it passes through Woolwich Reach, before bearing north-east into Bugsby's Reach. Within this long bend the mighty Royal Docks were built, a complex of three docks that covered, when in full operation, some 244 acres of continuous enclosed dock water, the largest such area in the world. Completed on marshland, the Victoria Dock was the first to be completed, in 1855. Nine years later, the dock was acquired by the London & St Katherine Docks Company who, well aware of the problems the narrow entrances to London's upper docks were causing for larger ships, created a second dock, extending in an easterly direction to Gallions Reach. The Royal Albert Dock was opened in 1880 and at the same time the existing Victoria Dock was also awarded 'Royal' status.

Even before the addition of a third dock, the 'Royals' were known for their principal commodities of chilled and frozen meats, tobacco and grain. In 1880, the first consignment of frozen meat and butter arrived in the Thames from Australia, whilst New Zealand's first meat shipment came to London two years later in the sailing ship *Dunedin*. The docks continued to be a hive of activity into the twentieth century, and the PLA, backed by government funds, proposed the construction of a huge 126-acre dock to the north. However, a less costly scheme for a 64-acre dock to the south of the existing docks eventually went ahead and the King George V Dock was completed in 1921.

The sheer size of the three-dock system, with over 17.7 km (12 miles) of quayside, enabled the handling of hundreds of vessels operated by famous shipping companies of the day. But the introduction of containerisation in the 1960s saw a steady decline in trade in favour of the downriver docks at Tilbury. Although the Royal Docks managed to survive commercially until 1981, they fell silent for a while until redevelopment saw the creation of residential complexes, leisure facilities and even an international airport.

Upstream from Bugsby's Reach the river passes Blackwall where the prospering East India Company would build its own ships during the seventeenth century. As its fleet expanded, the company developed a wet dock, known as Brunswick Dock, for the maintenance of its vessels, and this dock later became part of the commercial East India Dock, opened in 1806. After Blackwall, the Thames enters the most pronounced bend within its tidal waters, rounding the peninsula that is the Isle of Dogs. Today, the towering skyscrapers of Canary Wharf keep a watchful eye on the passing river traffic, this imposing business and residential centre having been created on the site of the West India Docks, the very first London dock system, opened on the northern half of the peninsula in 1802, and closed down in 1980. Immediately to the south on the Isle of Dogs, an L-shaped dock known as Millwall Dock was opened in 1868 with the intention of bringing in cheap foreign grain after the Corn Laws had been repealed.

Opposite the Isle of Dogs lies historic Greenwich, the centre of world time and overflowing with maritime heritage. Immediately upstream at Deptford is the site of King Henry VIII's Royal Dockyard where a large commercial wharf now operates. From Deptford the river swings northwards into Limehouse Reach and then to the left towards the Lower Pool. Here it rounds another peninsular that contains the Borough of Rotherhithe. To the west of Limehouse Reach, a large wet dock, called the Great Howland Wet Dock after the local landowners, was established around 1698. From 1763 it became known as Greenland Dock and was employed as a base for whaling ships. The year 1807 was important for this area, for it saw the completion of a new basin by the Grand Surrey Canal Company whilst, south of this, Greenland Dock was converted for cargo-handling. Thus Surrey Commercial Docks were born, although their prolonged development would take several decades and involve various individual dock companies, resulting in a group of haphazardly positioned docks that specialised in the timber trade until the final ship sailed out in 1970.

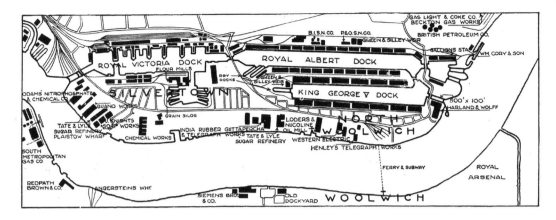

The Royal Docks – Three Decades of Change

The massive Royal Docks that stretch from Bugsby's to Gallions Reach. Since their closure in 1981 the shape and size of the three dock basins have not altered, but little else is the same. Numerous warehouses and dockside businesses are in evidence on the above map from the 1960s, but as the recent map below confirms, most have now left the scene.

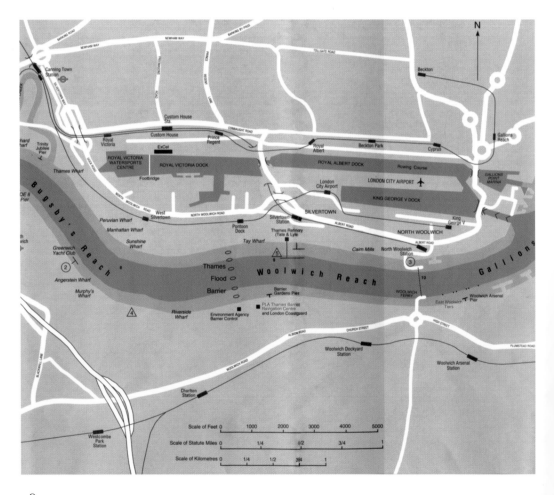

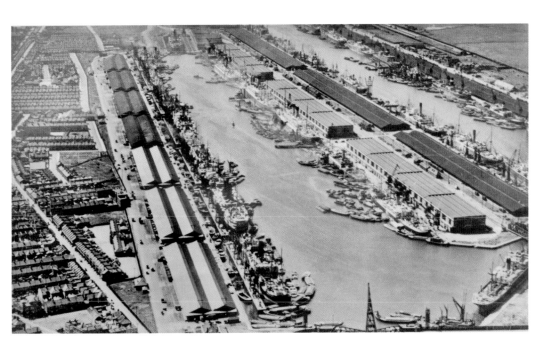

Ships to Aircraft
The Royal Albert and King George V Docks looking east in busy times. Note the abundance of lighters crowding around the ships. The Royal Victoria Dock is out of picture in the foreground. The London City Airport now extends across the centre quay between the two docks, its runway and a number of aircraft in view from the western end of the Royal Albert Dock.

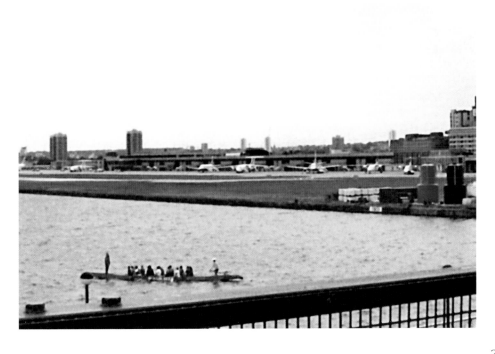

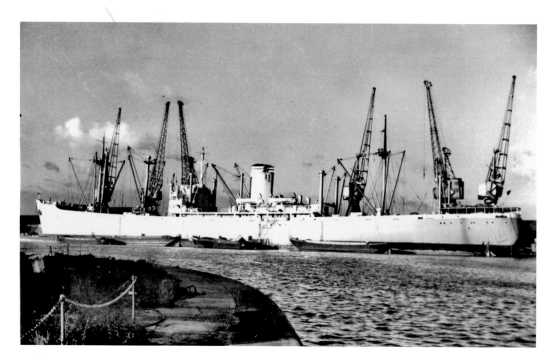

'Royal' Regulars

Ben Line cargo ships visited London's docks over many decades, trading on various routes worldwide. An example was the 8,800-grt *Benledi*, built in 1954, pictured in the Royal Albert Dock. The 'Royals' frequently hosted passenger-cargo liners and particularly those of the New Zealand Shipping Company. *Ruahine*, 1951/17,851 grt, was the company's last passenger-carrying vessel, equipped with 267 berths. Looking resplendent in the colours of Federal Line with whom her owners merged in 1965, she served the 'Royals' until 1968 when she became the cruiseship *Oriental Rio*.

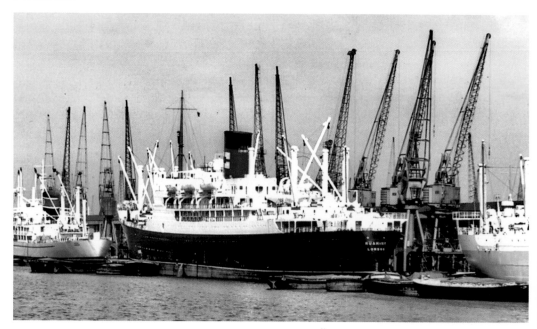

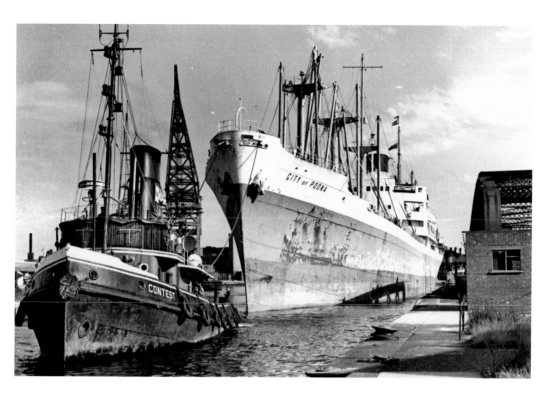

Commercial to Residential
Proudly showing off her handsome profile, the Elliott Steam Tug Company's *Contest*, 1933/213 grt, leads the Ellerman Line cargo ship *City of Poona*, 1946/9,962 grt, into the Royal Docks. Behind them stands the giant floating crane *London Mammoth*. Sadly, such evocative scenes are consigned to history as lengths of quayside are redeveloped with modern housing. At least a few of the original dock cranes have been saved.

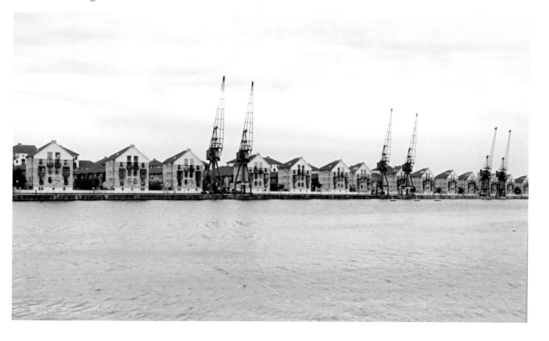

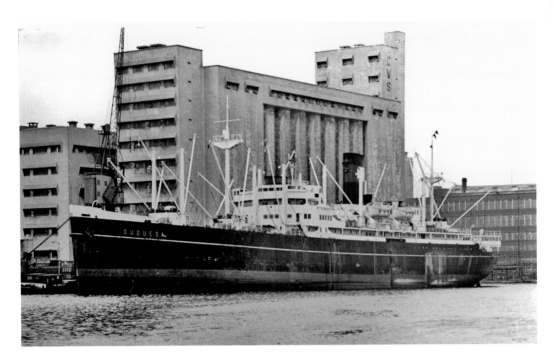

Co-operative No More

In the early twentieth century, three large flour mills were constructed on the south side of the Royal Victoria Dock, of which one was owned by the Co-operative Wholesale Society. Opened in 1901, it was later rebuilt as a concrete structure. Houlder Line's 11,007-grt *Duquesa* was one of the many cargo ships that could be seen discharging imported grain at the mill. A century later and the picture is very different: the CWS Mill was demolished in the 1990s and passenger jets now pass over the docks' still waters, bound for London City Airport.

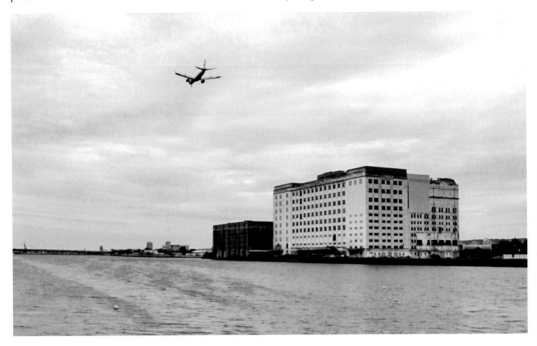

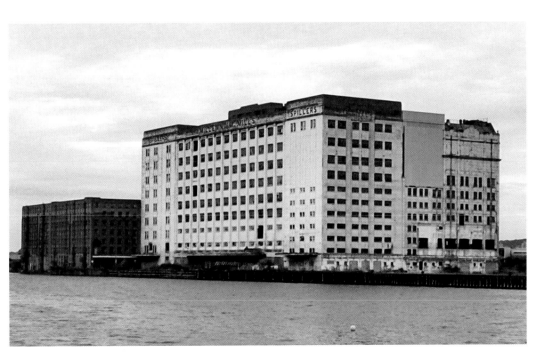

Grain of Hope

Of the three original flour mills established at Royal Victoria Dock only the granary of the Millennium Mills still stands. Founded in 1905, the Millennium Mills later became part of Spillers. Unfortunately, the surviving building is in a dilapidated state as it waits in hope of development, a far cry from the days when it would receive thousands of tons of grain offloaded from freighters such as *Continental Merchant*.

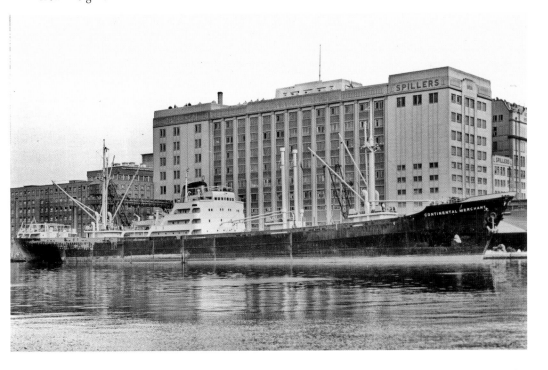

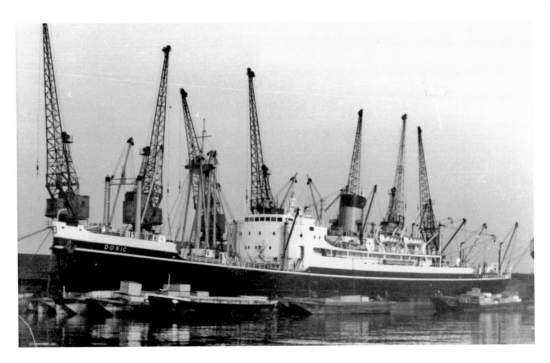

From Ships to Sport

British-owned vessels of the Shaw Savill Line were a regular sight in Royal Victoria Dock, bringing in meat, fruit and other produce from Australia and New Zealand. *Doric,* 1949/10,074 grt, pictured in dock during the sixties, sailed on the route until 1979. Dominating the giant dock's northern quayside today is the Excel Exhibition Centre, opened in November 2000. The venue for the London Boat Festival, it was chosen to host seven Olympic and six Paralympic indoor events in 2012.

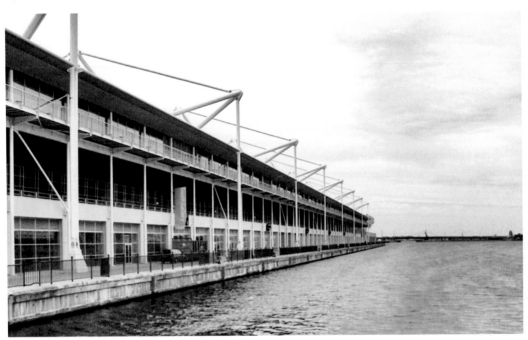

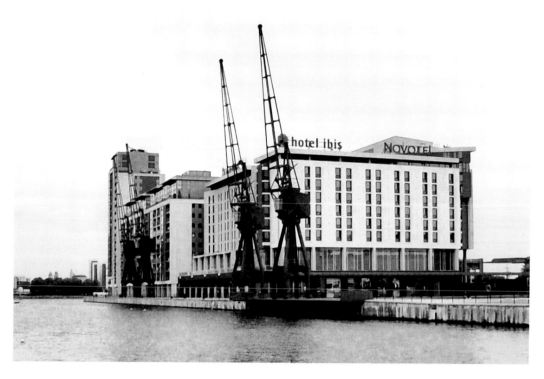

Ship to Shore

Fronting a modern hotel ibis and Novotel building also on the north side of Royal Victoria Dock, three dock cranes evoke memories of the days when liners such as *Cymric*, 1953/11,232 grt, would discharge their cargoes from the antipodes. A sister ship of Shaw Savill's *Cedric*, she was transferred to Royal Mail Lines as *Durango* in 1972.

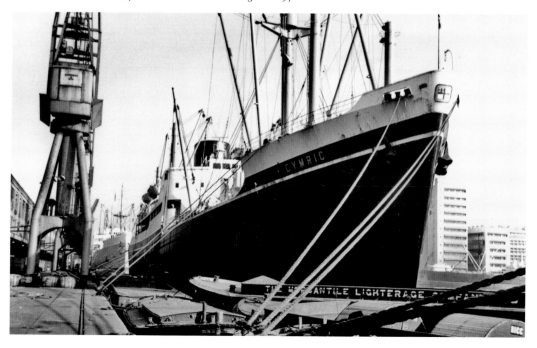

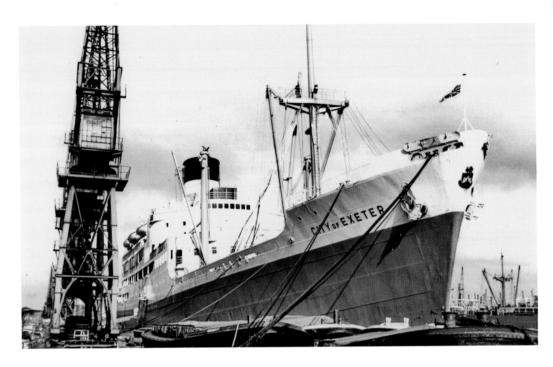

The Royal Albert

A member of a quartet of elegant cargo-passenger liners owned by Ellerman Lines, *City of Exeter*, 1953/13,345 grt, unloads in the Royal Albert Dock. With accommodation for 107 passengers, she would plough the ocean waves between London and Cape Town in fifteen days. Pictured in 1971, the year she was converted into an Adriatic ferry, this typical scene in the same dock shows lighters moored beneath the bows of the New Zealand Shipping Company's *Otaki*, 10,934 grt. Another freighter lies on the opposite side of the dock.

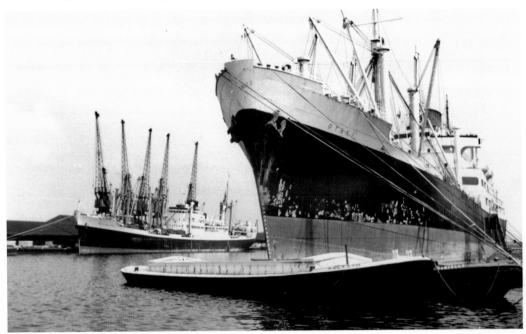

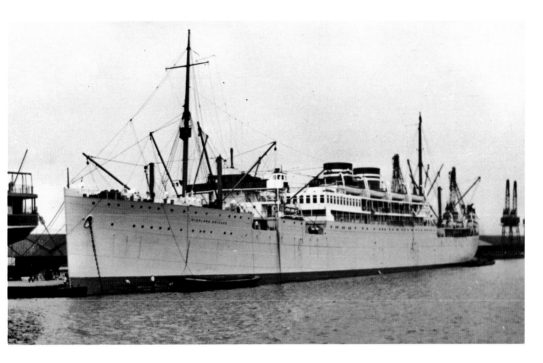

Royal Mail to London

Painted in her original Nelson Line colours, the passenger-cargo liner *Highland Brigade*, 14,131 grt, discharges refrigerated produce from South America in the Royal Albert Dock in July 1932. With her three *Highland*-class sisters she came under the ownership of Royal Mail Lines later that year, following a company merger, but continued to ply between London and Buenos Aires for the remainder of her commercial career. By 1960, the trio had been replaced by three larger sisters, including the good-looking *Aragon*, 20,362 grt, that was employed on the route for only nine years.

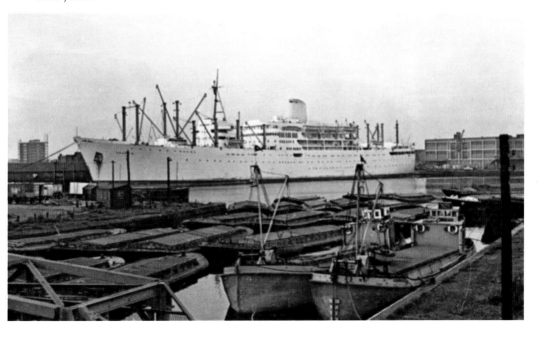

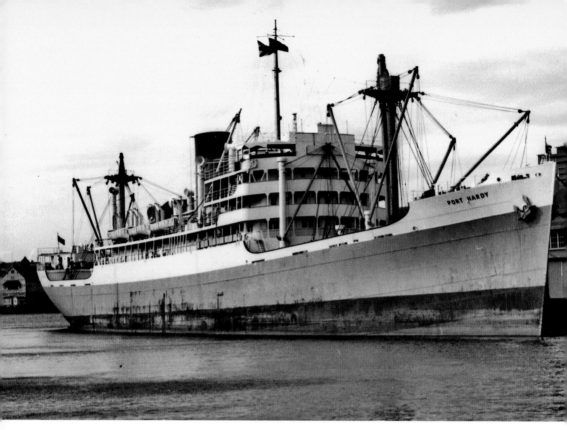

Port Line Ships in the Royals
Cargo vessels of the Port Line that specialised in conveying refrigerated produce from Australia and New Zealand were habitual visitors to the Royal Docks. *Port Hardy*, 1944/8,320 grt, was built for Bibby Line as *Herefordshire,* but chartered to Port Line from 1954 to 1961. A few original warehouses in the Royals still exist, such as this building alongside Royal Victoria Dock that has been reopened as a brasserie.

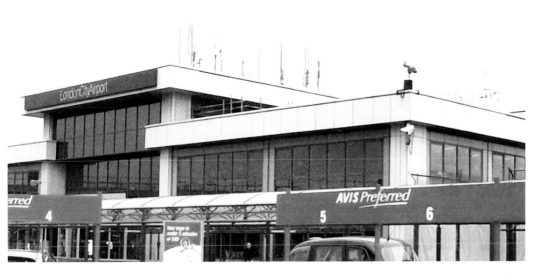

London City Airport and a Former Dock

The entrance to London City Airport where cranes and warehouses once stood. The airport is the leading commercial enterprise in the King George V Dock area. A mid-twentieth-century scene in the dock shows the steam tug *Racia*, 1930/163 grt, an incoming Blue Funnel or Glen Line ship to the left and the passenger-cargo liner *Dominion Monarch*, 1931/26,463 grt, the largest consistent visitor to the Royal Docks, behind them.

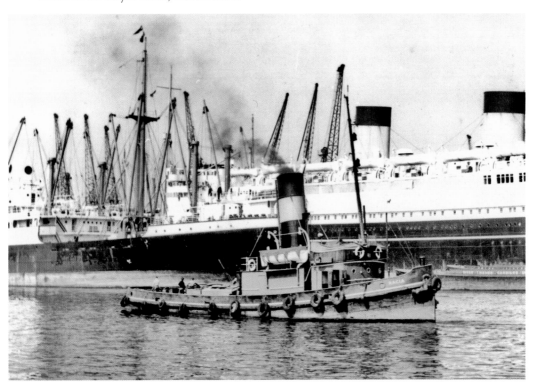

Final Deliveries

One of four cargo-passenger ships built for Blue Star Line's South American service, *Argentina Star*, 1947/10,716 grt, lies in King George V Dock in April 1972, just six months prior to ending her days at the breakers. As trade to London's docks subsequently began to slip away, many more British vessels ceased using the 'Royals' and by the end of 1980 only seven berths remained operational in the whole three-dock system, including one specialising in the Chinese trade. The 1974-built *Han Chuan*, 10,744 grt, was one of the last cargo vessels to berth in the docks.

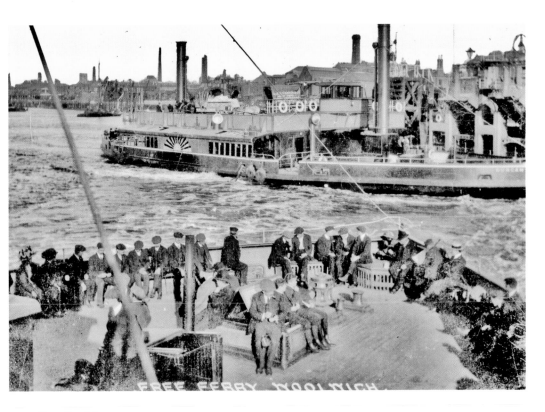

Free for All

When man and his cap were never apart. Two 490-grt paddle steamers had inaugurated the Woolwich Free Ferry that remarkably has remained free of charge to this day. The *Duncan* and the *Gordon*, both dating from 1888, were followed by a third ship, the *Hutton*, in 1893.

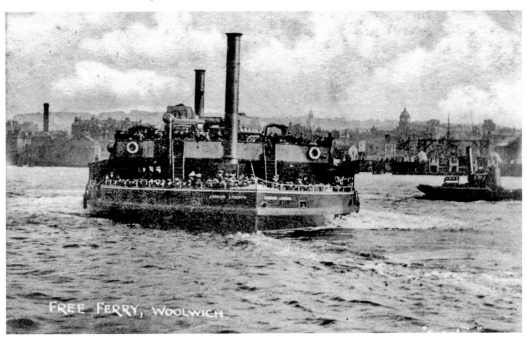

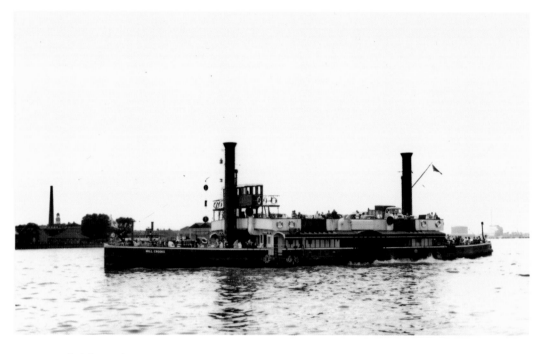

Later Woolwich Ferries

The first three ferries on the Woolwich crossing were eventually replaced by four new paddle steamers, all offering the same 1,000-passenger capacity. The *Squires* and the *Gordon* (II) came into service in 1922 and the *Will Crooks* (pictured) and *John Benn* by 1930. The current vessels – the identical *Ernest Bevin*, *John Burns* and *James Newman*, all 1963/739 grt, are equipped with a propulsion system that holds them in position against the piers without the need for them to tie up.

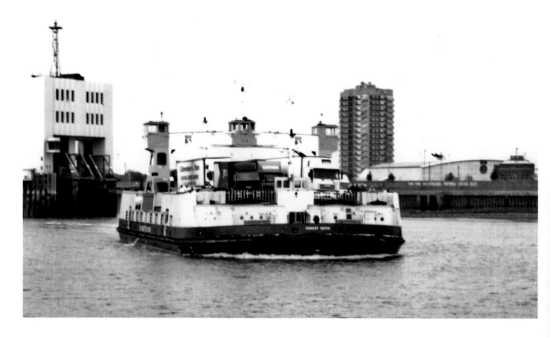

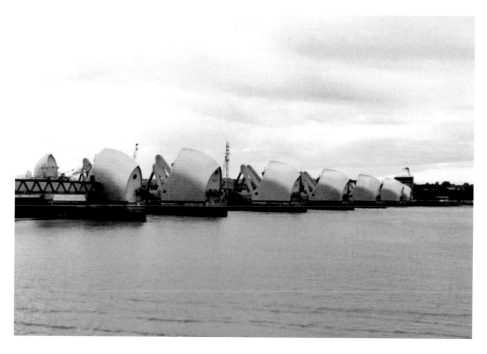

London's Flood Barrier

The world's second largest moveable flood barrier, the Thames Barrier, was constructed across a 520-metre stretch of the Thames between Silvertown and New Charlton. Work began in 1974 and culminated with the Barrier's official opening by HM The Queen on 8 May 1984. There are four 61-metre and two approximately 30-metre navigable spans. Subsequent riverside improvements were made, and in November 2000, the award-winning Thames Barrier Park was opened on a 22-acre site taken over by the London Development Agency.

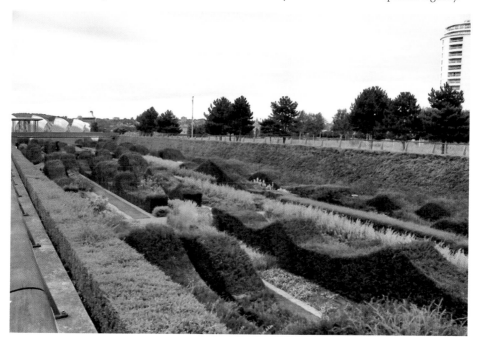

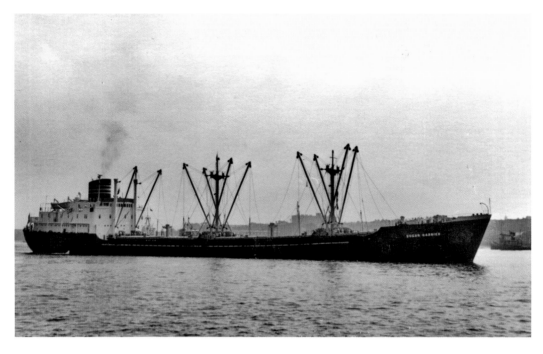

A Sweetener for the Port of London

In 1921, two rival sugar refiners, Henry Tate & Sons at Silvertown and Abram Lyle & Sons of nearby Plaistow merged to form the Tate & Lyle Company. Although its Silvertown headquarters was badly damaged in the Second World War, Tate & Lyle joined forces with the United Molasses Company in 1950 to form a new shipping company, Sugar Line. The 6,358-grt *Sugar Carrier* was a typical fleet member. The line no longer exists, but large modern bulk carriers operated by various shipping companies regularly discharge at the refinery's jetty.

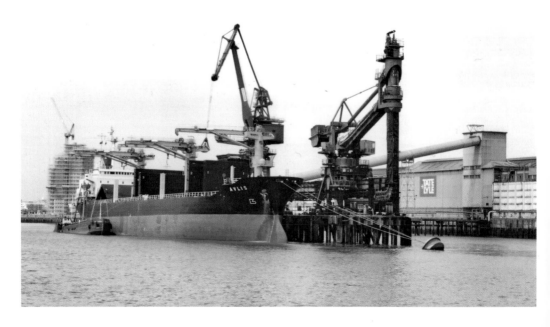

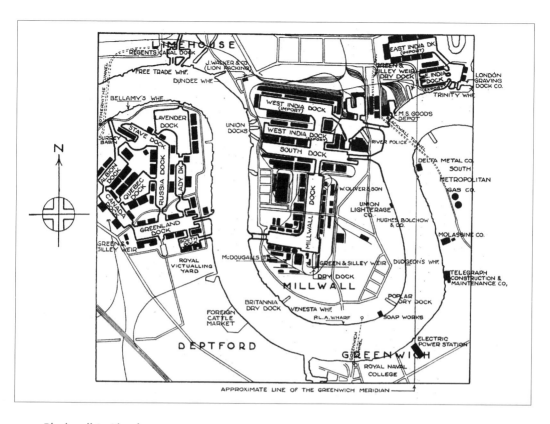

Blackwall to Limehouse

Where the River Thames loops dramatically around the Isle of Dogs, four sets of enclosed docks were built. As shown on this map dating back half a century or more, entrances to the East India Docks at Blackwall and the West India and Millwall systems would be passed on a journey upriver, before the river swings past Greenwich and Deptford towards Limehouse and the main entrance to the Surrey Commercial Docks at Rotherhithe. Today, on the south bank immediately east of the Blackwall Tunnel stands the O₂ Centre, formerly the Millennium Dome, and now a successful 23,000-seat concert arena and venue for the 2012 Olympic gymnastics and basketball finals and also the Paralympic wheelchair basketball.

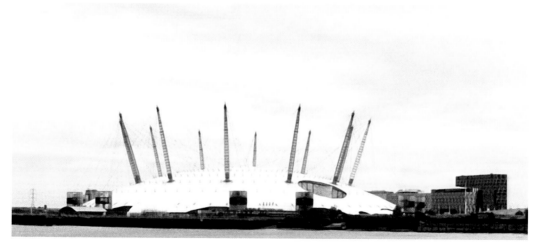

The Fleet's In

Steamers of the Union Castle Line berthed in the East India Docks before the outbreak of the First World War. This was home for the Union Castle fleet, which carried passengers, mail and cargoes between London and South Africa. The docks were rather restrictive in size and after a while ocean liners gave way to the short-sea trade, including Coast Line vessels such as the 1,560-grt *Caledonian Coast*, built in 1948. Following their closure in 1967, East India Docks were mostly filled in, with only the entrance basin remaining.

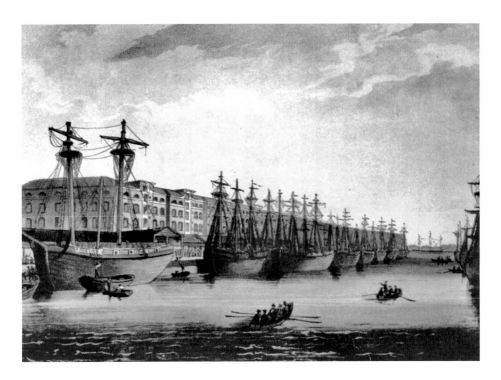

Docks Full of History
An early view of West India Docks, dated around 1810. Impressive tall warehouses that handled cargoes of West Indian sugar, rum and coffee rise almost as high as the masts of the sailing vessels lining the dockside. Nine warehouses stretched the length of the Docks' north quay and in No. 1 Warehouse the Museum of Docklands, which traces the development of the Port of London from Roman times, was opened by HM The Queen in the summer of 2003.

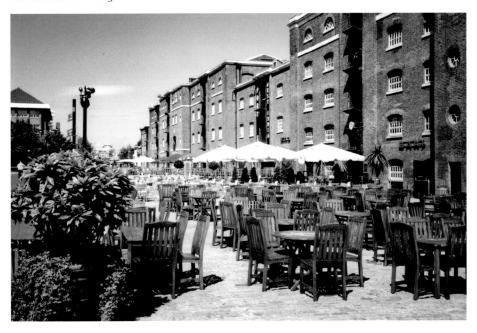

A Princely Entrance

African Prince, 1939/4,653 grt, approaches the Thames to complete another voyage from the Mediterranean. Cargo vessels of the Prince Line regularly used West India Docks, entering from Blackwall Reach to the east, the only lock entrance serving the entire West India and Millwall system. As described on this plaque this arrangement still applies today, although the entrance leads to a very different picture.

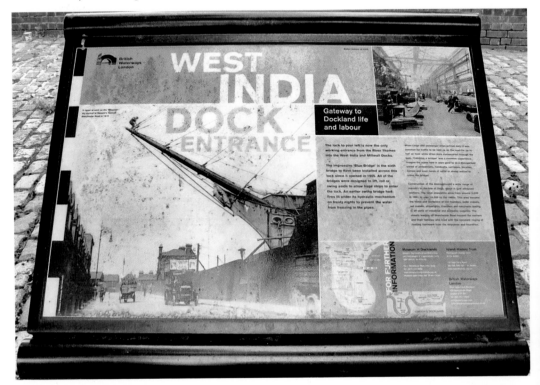

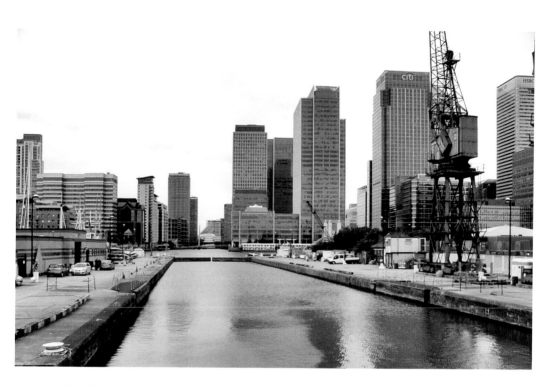

Blackwall Basin

The present view from the Blackwall Basin towards the mighty towers of Canary Wharf. Where thousands of business people scurry to and from their offices every day, ships such as Harrison Line's freighter *Barrister*, 1954/8,368 grt, would tie up at the West India Docks quaysides.

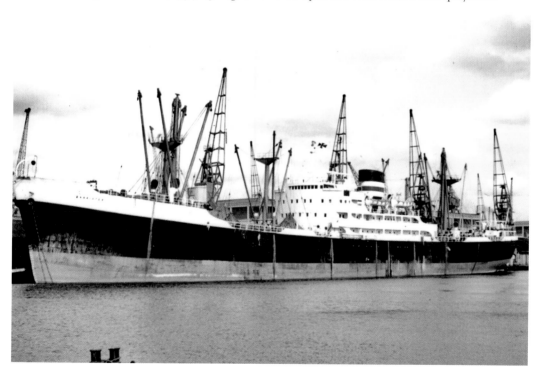

Little and Large

Nowadays, the only craft to use the waters of Millwall Docks are those from the Docklands Sailing Centre, located at the western end of the Outer Dock. Yet, in their heyday, the docks would host cargo vessels as large as the 10,071-grt *Patonga* that operated on P&O's Australian service.

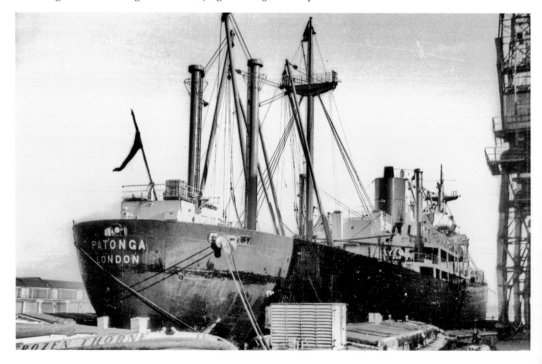

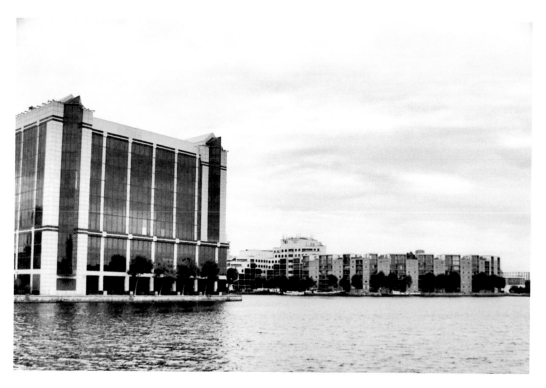

Millwall's Changes

The waters of Millwall Docks may have remained, but everything else has changed. *Trentino*, 1952/2,340 grt, seen in the docks in the early 1970s, was one of the smaller vessels to take on her cargoes there. Owned by Ellerman's Wilson Line, she was employed on the company's UK–Baltic ports route.

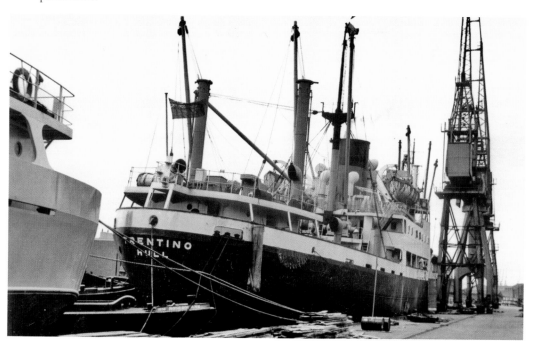

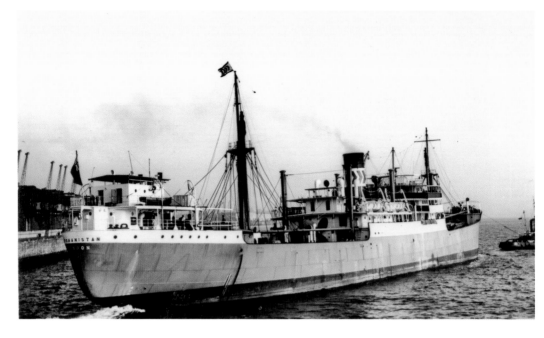

The 'Stans' of Millwall

Ocean freighters owned by Frank C. Strick & Co. were frequent visitors to the Millwall Docks. *Afghanistan*, 1940/6,992 grt, was a typical member of the fleet (all their names had the suffix *Stan*), that operated worldwide. The warehouses of Millwall's Outer Dock have all now disappeared, replaced by residential property.

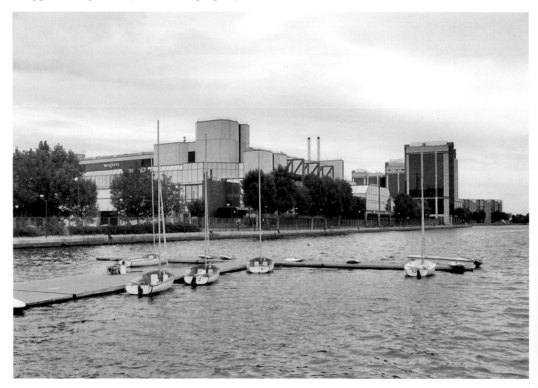

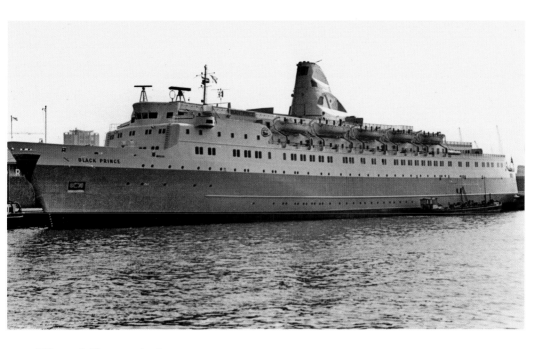

Winter Sailings to the Sun

Before her days as a well-loved cruiseship, the 9,499-grt Norwegian ferry *Black Prince*, owned by Fred Olsen Lines, spent her winters sailing between Millwall Docks and the Canary Islands in tandem with her identical sister *Black Watch*. Built in 1966, each vessel could accommodate 350 passengers and would bring in more than 3,000 tons of fruit and tomatoes to the Inner Dock where, in 1969, dedicated passenger and cargo terminals were opened. Today, the much-altered dock is watched over by the soaring buildings of Canary Wharf.

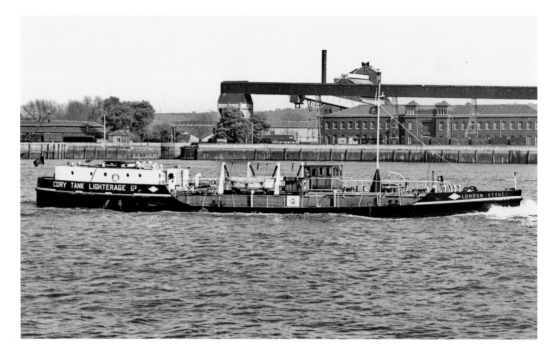

All Change in Greenwich Reach

During the trading days of London's upper docks and wharves a multitude of various small craft would come and go past Greenwich. Among those were river tankers such as *London Stone*, 1957/438 grt, operated by the Cory Tank Lighterage Company. Today, the scene is so different as streamlined river cruisers convey sightseers from the historic waterfront to London locations upstream.

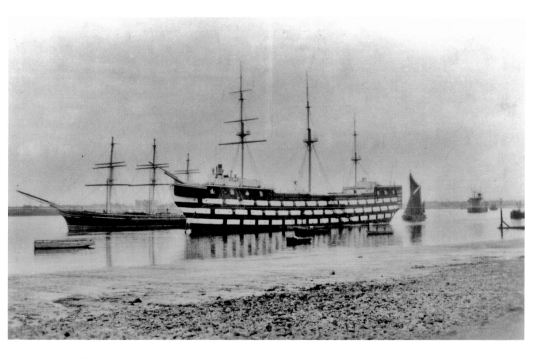

A Legend Lives On

The former tea clipper *Cutty Sark*, 1869/972 grt, which graced the East India Docks in her commercial years, moored off Greenhithe with the third *Worcester*, 1904/5,480 grt, a static training ship. *Cutty Sark* completed her final sea passage in 1938 when she was towed to Greenhithe and opened as a public attraction in her own dry dock at Greenwich in 1954. On 21 May 2007, while undergoing refurbishment, she was ravaged by fire, but miraculously her most valuable assets were saved. She was due to reopen to the public in the spring of 2012.

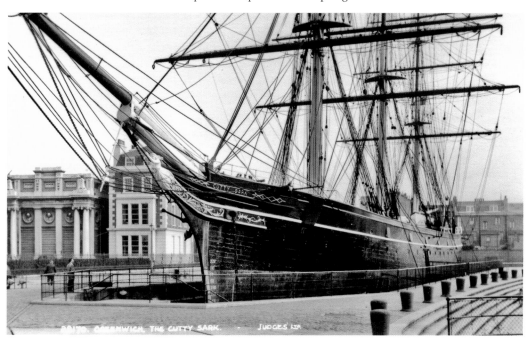

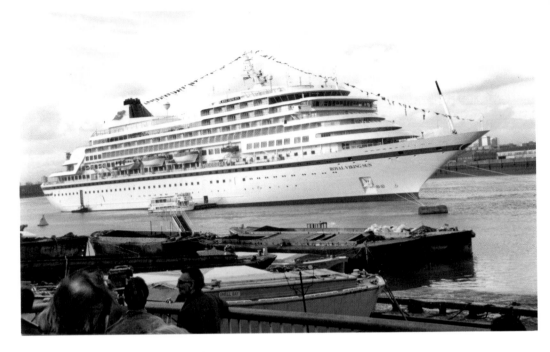

Greenwich – A Cruiseship Destination

With its international fame and proximity to Central London, Greenwich is a natural UK cruise destination. On 29 November 1988, the 37,845-grt *Royal Viking Sun* arrived direct from her Finnish builders and hosted a gala charity dinner attended by HRH Prince Charles. This highly rated ship now cruises as Holland America Line's *Prinsendam*. A very different-looking cruise ship in the shape of the twin-hulled *Radisson Diamond* sailed up the Thames to be named at Greenwich Ship Tier on 28 May 1992. Her unique design, however, proved less successful than expected and she was sold to a Hong Kong owner in 2005.

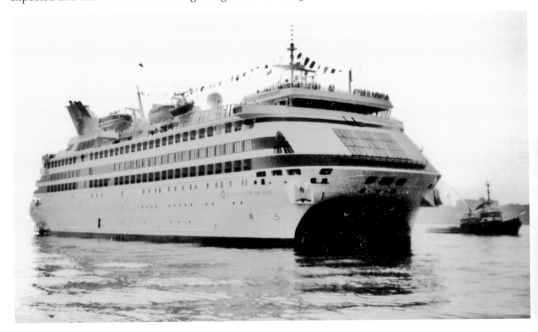

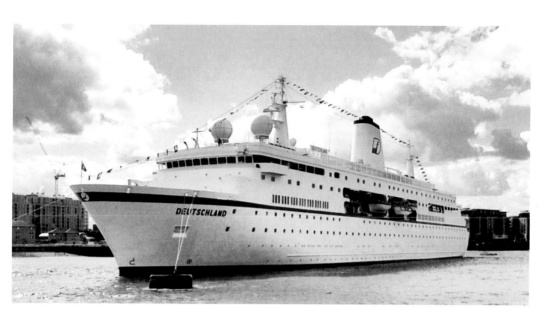

Greenwich Ship Tier

A new floating cruise terminal – the world's first – now offers increased comfort and service at Greenwich Ship Tier for cruise ship passengers. Vessels of up to 240 metres in length can moor there, an annual visitor being the pristine German cruise vessel *Deutschland*, 1998/22,496 grt. During the 2012 Olympics, when an influx of passenger ships are scheduled to visit London, the luxurious 28,258-grt *Silver Whisper*, completed in 2001, is using the Greenwich facilities.

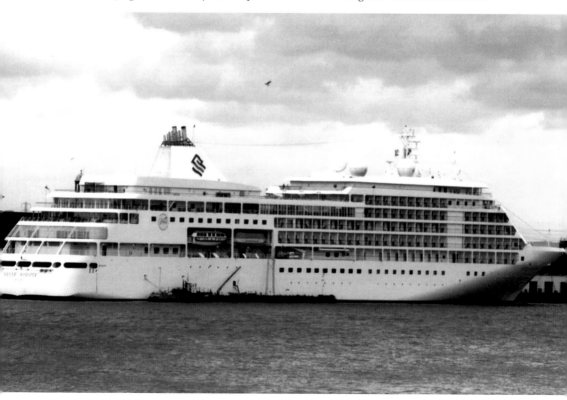

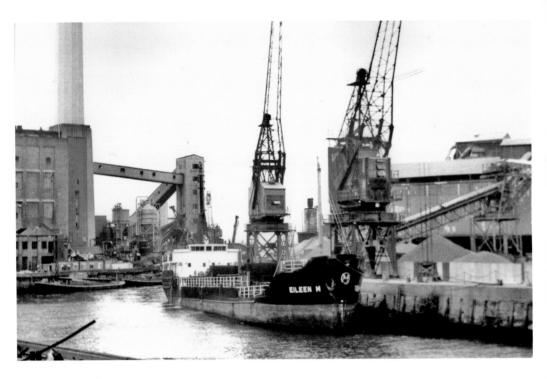

A Historic Creek

The 1,000-metre tidal stretch of the River Ravensbourne known as Deptford Creek should be proud of its illustrious past, for it encompassed everything from shipbuilding to shipbreaking, had a power station by its entrance and was even visited by the famous diarist Samuel Pepys. The British coaster *Eileen M* is tied up at one of its wharves amid a plethora of local industries. Deptford Creek is now closed to commercial shipping and has been redeveloped. A sailing boat passes its entry into the Thames near Greenwich.

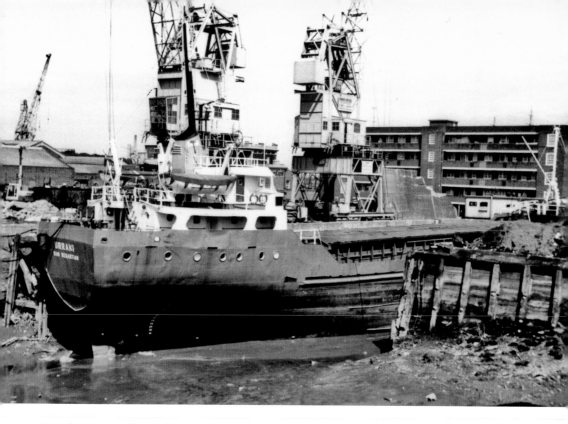

Deptford Yesterday and Today

Another view of Deptford Creek, dating from 1980. The Spanish coaster *Urraki*, 1975/723 grt, sits on the mud, awaiting the tide. Deptford's principal ship-handling facilities today are at Convoys Wharf on the south bank of the Thames. Dealing with imported newsprint, it stands on the site of King Henry VIII's sixteenth-century Royal Dockyard.

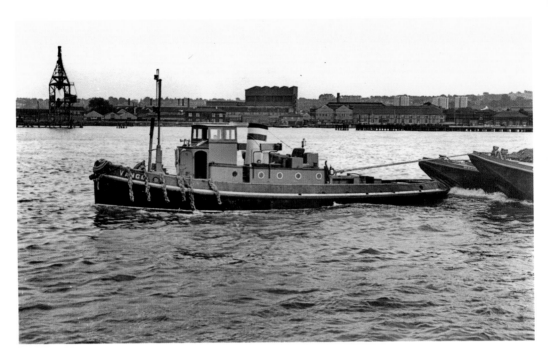

Lighters – A Rare Breed

A view from the fifties – the little tug *Vange* pulls her load upstream. At the end of that decade no less than 80 per cent of all cargo coming into the Port of London was discharged into lighters, providing work for 5,500 lightermen. Now only a small number of lighters remain, including this rather lonely one, displaying the PLA's full name.

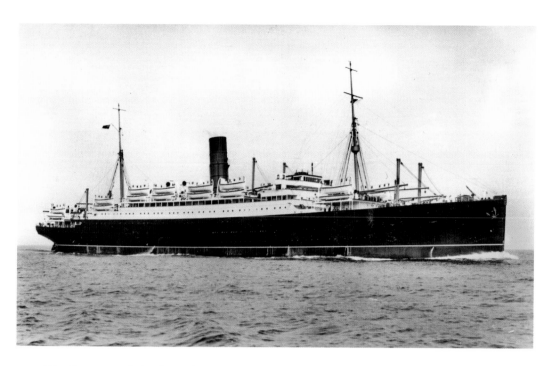

The Surreys and the Cunarders
The main entrance to the Surrey Commercial Docks viewed from Limehouse Reach, as it is today. Through its vast 229-metre-long lock, leading directly into Greenland Dock, would frequently pass five 'A'-class Cunard Liners, the largest and most impressive ships to use the Surrey system during the interwar years. One of these, the 13,912-grt *Ausonia,* was built in 1921 and designed to accommodate 300 cabin and 1,200 third class passengers. The quintet would ply the North Atlantic to Canada in the summer and Nova Scotia in the winter months.

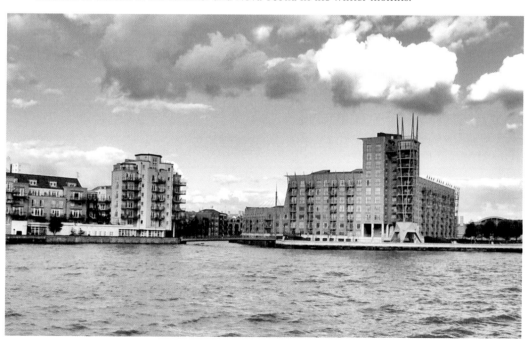

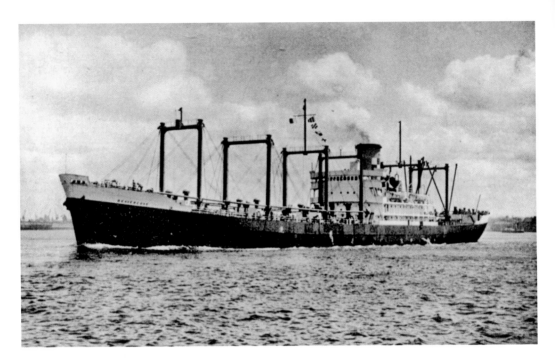

Beavers from Canada

Although the softwood trade very much belonged to the Surrey Commercial Docks – at least 80 per cent of all timber was handled there – dairy produce and grain from North America were also offloaded. *Beavercove*, 1947/9,824 grt, was employed by Canadian Pacific Steamships on their London–Canada route in the company of six similar vessels that would regard the Surrey Docks or Royal Docks as home. They had replaced five 1920s-built *Beaver* ships that had all been war losses, including *Beaverdale*, 1928/9,957 grt, (below) torpedoed in the North Atlantic in April 1941 with the loss of twenty-one lives.

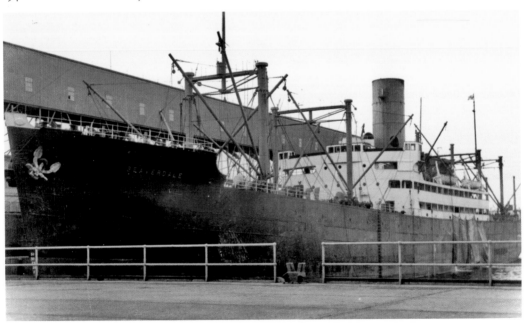

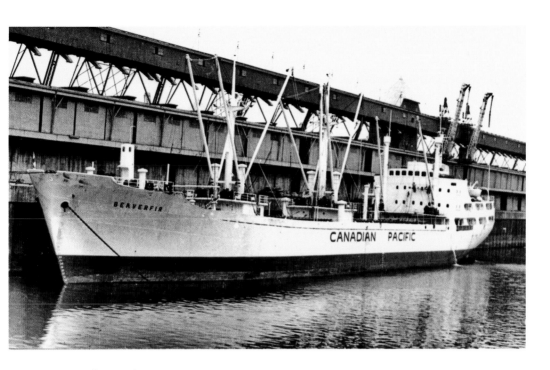

From North America

In the 1960s, a new breed of *Beavers* took over the North Atlantic cargo route for Canadian Pacific. *Beaverfir,* 1961/4,539 grt, looks especially smart in her all-white colour scheme. Since their closure to shipping, the Greenland Dock's quays, over which North American goods would pass, have been turned into tree-lined residential avenues, while the locals have fun speeding across the dock waters.

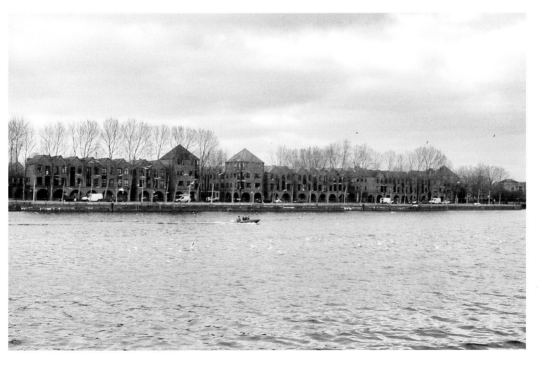

Greenland Dock

The huge expanse of the 22-acre Greenland Dock can be appreciated in this view towards the entrance lock and Surrey Watersports Centre at its eastern end. Canary Wharf, on the Isle of Dogs opposite, is evident in the background. Among the larger vessels that used the dock in its commercial years were those of Furness Withy & Company, including *Pacific Reliance*, 1951/9,337 grt, that had defected to the Royal Docks for this 1971 photograph.

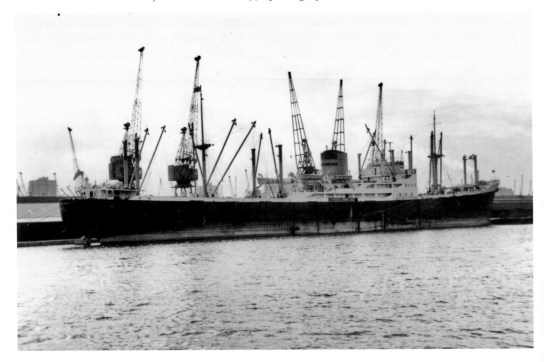

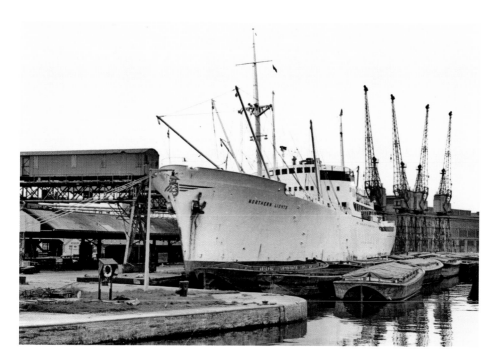

Timber Ships and the South Dock

The 1950-built Norwegian cargo ship *Northern Lights* was typical of the workaday timber carriers that would enter the Surrey Commercial Docks. Like the adjacent Greenland Dock, South Dock has survived in its complete form to today. Seriously damaged during the 1940 London Blitz, it was emptied of shipping in 1944 for the construction of concrete sections for the Mulberry Harbours used in the D-Day landings. Thanks to funding from the London Docklands Development Corporation, unique buildings, such as Baltic Quay, located at the far end of the dock, have been created. London's largest marina, with over 200 berths and mainly occupied by yachts and residential barges, was opened in the dock in 1994.

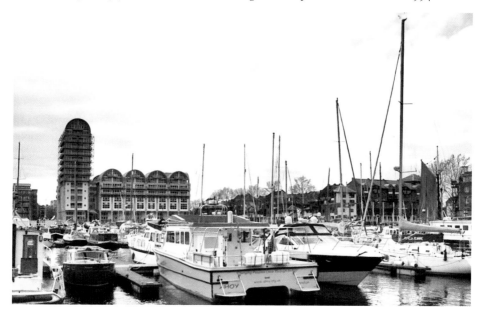

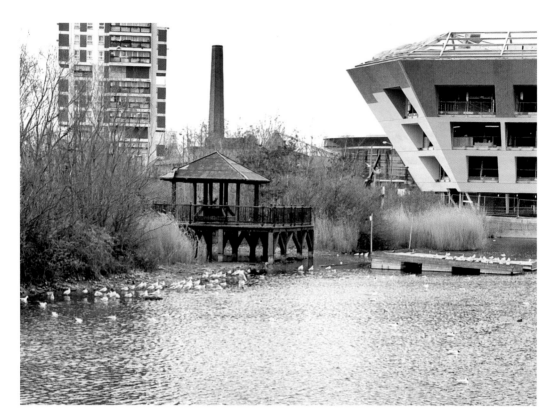

From Ships to Shops

Canada Dock was added to the complex Surrey Docks system in 1876 and was thereafter constantly crowded with timber-laden ships. Following its closure, about half the dock basin was retained and now, as Canada Water, it features a freshwater lake and wildlife reserve. At one end a futuristic-looking library (partly hidden in this view) has been built. The remainder of the original dock was filled in and the area is occupied by a shopping centre and car park.

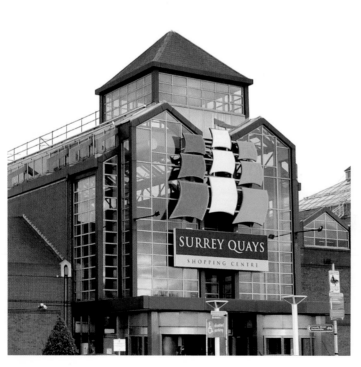

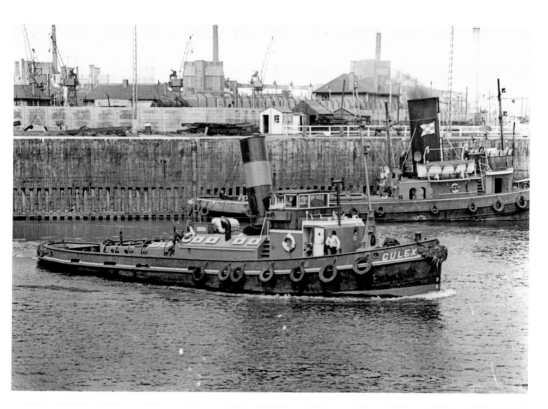

Upriver Tugs

The little Gaselee tug *Culex* was based in Limehouse Reach, to the west of the India & Millwall Docks. Behind her is a large Elliott steam tug. Several years on, the Adsteam tug *Sun Anglia* takes a break upriver. Adsteam's towage operations in the Thames are now in the hands of Svitzer.

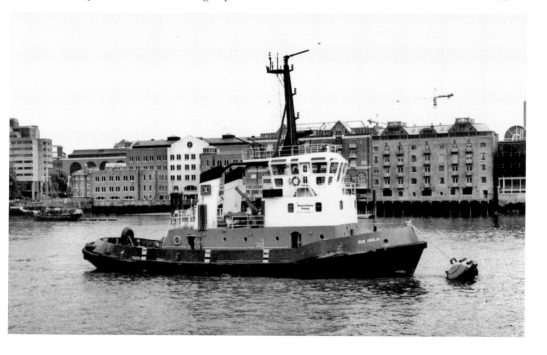

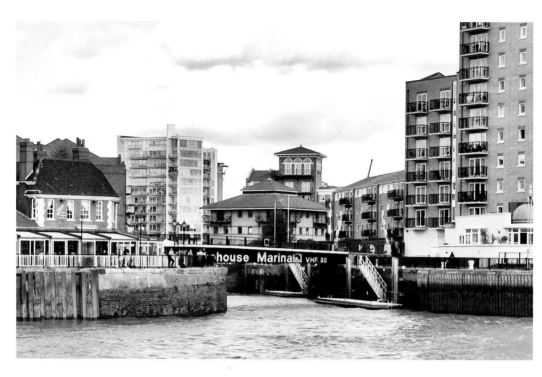

Limehouse and Beyond

The entrance to Limehouse Marina, a haven for small craft and formerly the Regent's Canal Dock. Opened in 1812 as a barge basin leading to the Regent's Canal itself, it was owned by the British Waterways Board and was never part of PLA operations. Small coastal and short-sea cargo vessels of the General Steam Navigation Company, such as *Auk*, 1939/1,238 grt, would serve the dock and numerous upriver wharves between Limehouse and the Upper Pool.

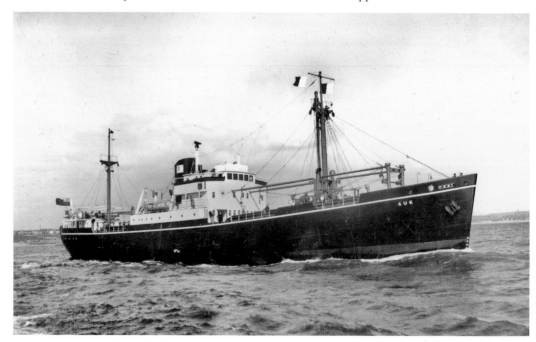

chapter 3

Lower Pool to London Bridge

On the final leg of the upriver journey to Central London, riverside wharves become increasingly prevalent, although the loss of trade to deepwater berths downstream has led, in recent years, to the faithful restoration of many old warehouses and their conversion into quality residential apartments.

In the sixteenth century, considerable chaos reigned throughout London's port as ever-increasing numbers of ships crowded the river and its many wharves. This in turn led to a corresponding upsurge in the smuggling of dutiable goods and an Act of Parliament was passed in 1558 for the designation of more than 400 metres of quayside on the north bank as 'legal quays'. Cargo handled here had to be cleared by appointed customs officers. Soon, further quays, known as 'sufferance quays' (so called because their owners could lose their grants should any illegal activities be discovered) were established further downriver.

For the construction of London Docks, opened in January 1805, people and businesses of Wapping were uprooted from their premises, an unpopular and costly affair. Among the cargoes handled were brandy, rice, tobacco and wine and warehouses featured extensive ventilated wine vaults – among the most impressive cellarage in London. London Docks were closed in 1968 and the site was bought by the London Borough of Tower Hamlets in 1976. Today, little evidence of the docks remains, almost all having been filled in.

Squeezed in between London Docks and the Tower of London, St Katharine Docks were completed in 1828. The project caused even greater upheaval and unpopularity than the neighbouring London Docks scheme as no fewer than 11,300 people had to be re-housed, the historic hospital of St Katharine, founded in the twelfth century, was pulled down, and gone also, amid great local sadness, was the church of St Katharine. Thomas Telford was appointed engineer, overseeing the construction of two docks, Western and Eastern, joined by a 1 ½ -acre basin linked by a lock basin to the Thames. Valuable goods, such as ivory, marble and turtle shells, would be handled, although a variety of other cargoes, from rubber to glucose and wool to perfumes, would be offloaded from ships and lighters into warehouses whose frontage reached the very edge of the quaysides. Despite heavy war damage, St Katharine's Docks continued trading until 1968 and thanks to subsequent redevelopment they proudly partner the Tower of London and Tower Bridge as one of London's most appealing riverside attractions, offering superb marina facilities.

The journey has reached the Pool of London and is now complete. From this point on, black-hulled colliers used to convey coal to London's numerous Thames-side power stations and gasworks further upstream. Now they are gone, the waters are mainly populated by modern river cruisers carrying sightseers and commuters, signalling the way forward for the upper reaches of London's great old river.

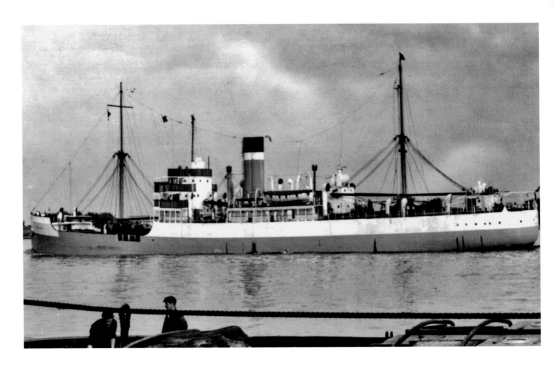

Ellermans to London

One of Ellerman Line's smaller cargo vessels, the 2,305-grt *Algerian*, built in 1924, makes her way toward London Docks. She was registered to lay a UK–Norway petrol pipeline during the Second World War and was broken up in 1957. Ellerman vessels berthed in the upper dock systems for many years, bringing in goods from Continental and Mediterranean ports. A later example was *Maltasian*, 1950/3,910 grt.

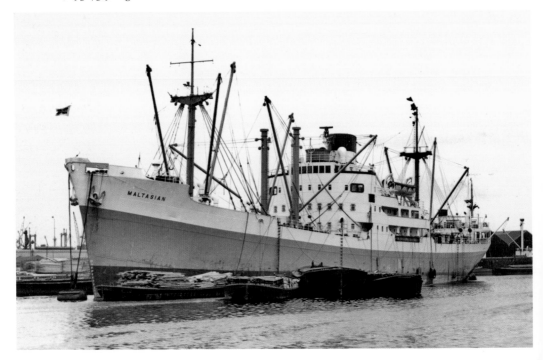

London Docks' Changes

The London Docks at Wapping handled a considerable amount of lighterage hauled upriver by small tugs from ocean cargo ships berthed in the docks and at wharves downstream. Following its closure, the majority of the dock waters were filled in, but redevelopment was initially slow. More recently, residential property has evolved along the Wapping riverside, whilst the docks' original entrances are still in evidence.

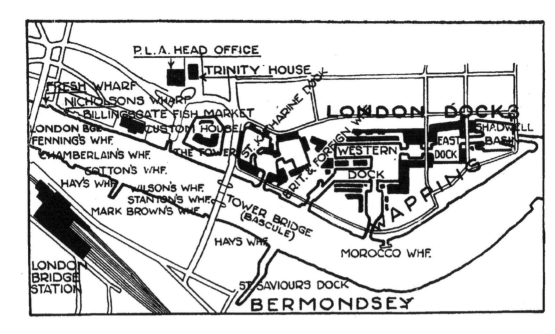

Upper Docks and Wharves

The most congested area within the Port of London. As this 1960s map indicates, dock systems and countless wharves are crammed within a short stretch of the river. St Katharine's Docks were opened on 25 October 1828 when, amid great pomp and splendour, the 700-ton *Elizabeth* sailed in, carrying survivors of the Battle of Trafalgar on deck.

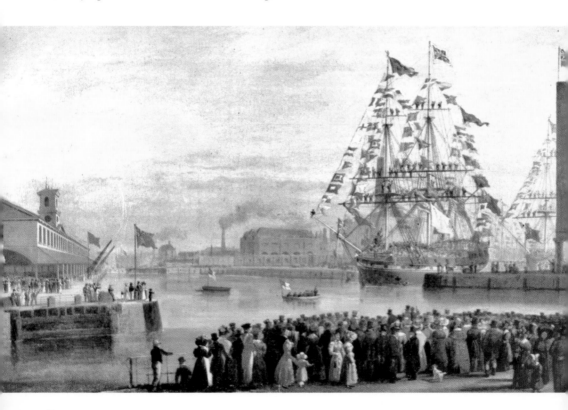

The Same Entrance

In a picture that evokes many stories despite its lack of clarity, the General Steam Navigation Company's motor vessel *Bullfinch* passes through the St Katharine's Docks entrance lock during the 1930s. In the Second World War she was heroically involved in the evacuation of Dunkirk, surviving to tell the tale. The clock tower of the former Ivory House ahead of her used to house the docks' call-on bell. As black and white turns to digital colour, and private leisure craft move through the same entrance, Ivory House appears much the same, although it now contains luxury flats and shops.

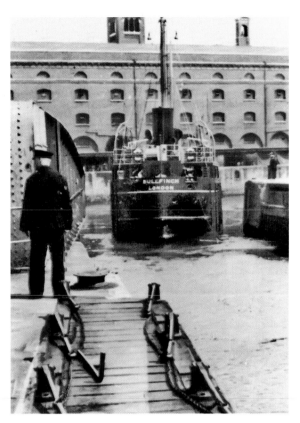

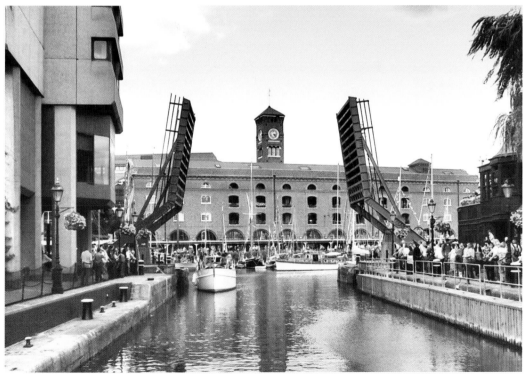

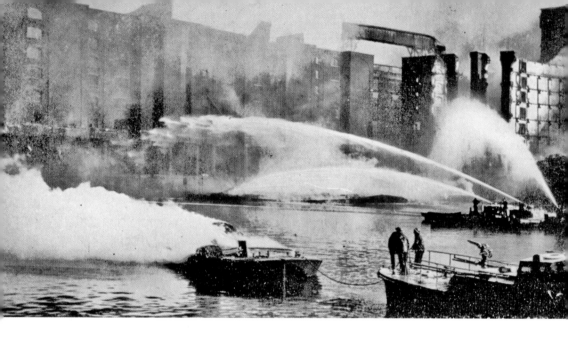

Rebuilt from Devastation

Firefighters attempt in vain to save the blazing warehouses of St Katharine's Eastern Basin during the London Blitz of September 1940. Nazi bombs caused extreme devastation to the West India and Surrey Dock systems as well as St Katharine's where the site of the warehouses remained empty until the dock's closure in 1968. Recent developments have seen the construction of apartments on the site, thus ensuring that St Katharine's Docks are once again enveloped by buildings.

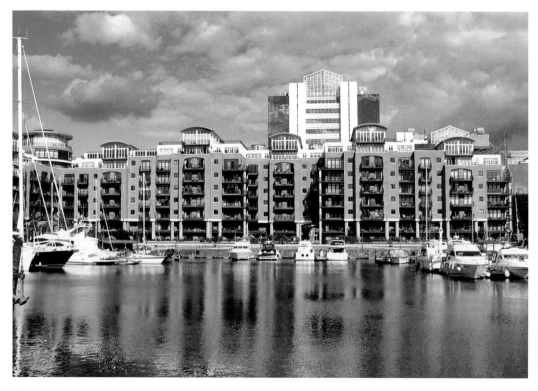

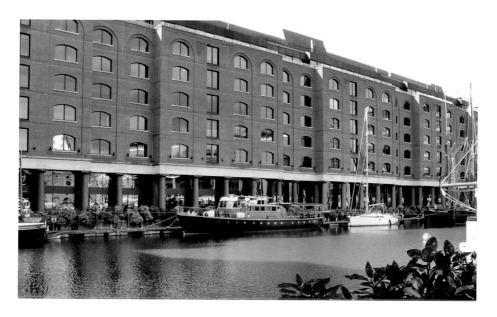

The Western Basin

St Katharine's Docks' Western Basin as it is today. The restoration of the docks began in the 1970s and they now thrive as a yacht marina and a base for Thames barges. In the centre is the former PLA launch *Havengore* that conveyed Sir Winston Churchill's coffin up the Thames during the solemn proceedings of 30 January 1965. During the annual Thames Festival St Katharine's Docks come alive as various private craft cram into the basins amid much entertainment.

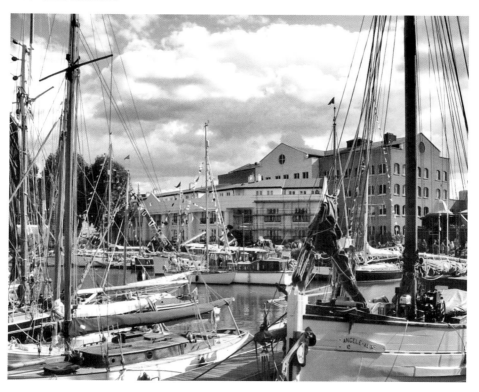

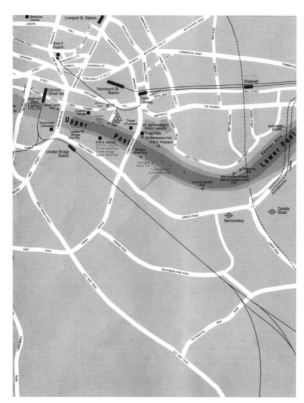

Mapping the Changes

A recent map of the Lower and Upper Pools. Although, as this shows, London's wharves have mostly disappeared, a few have been sympathetically converted, retaining much of their original appearance. Metropolitan Wharf, on the north bank at Wapping, was built between 1862 and 1890. Today, it contains housing, office space and even a children's theatre.

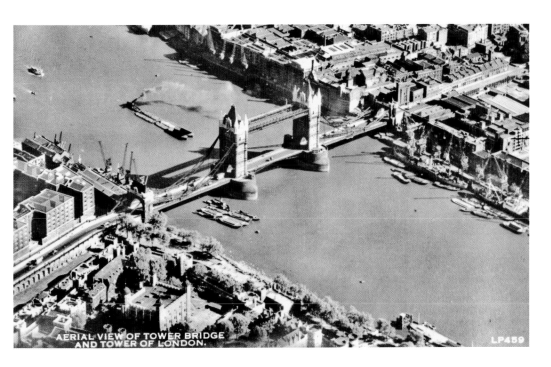

AERIAL VIEW OF TOWER BRIDGE AND TOWER OF LONDON. LP459

London's Pool

A bird's-eye view of the Pool of London when the commercial wharves and upper docks were still very much in business. On the left, immediately downriver from Tower Bridge, are Irongate Wharf and St Katharine's Wharf, just outside the St Katharine's Docks. On the opposite bank, to the top of the picture, is Butlers Wharf. Built in 1871–73, it once contained the world's largest tea warehouse. Closed in 1972, it was initially derelict, but following conversion it is now known for Terence Conran restaurants and contains the London Design Museum.

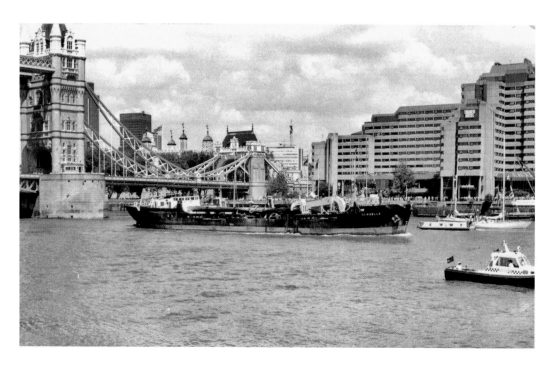

A Tragic Event Remembered

The sand dredger *Bowbelle,* 1964/1,465 grt, entering the Lower Pool in July 1989. Note the Tower Hotel behind her, completed in 1973 on the site of the Irongate and St Katharine's Wharves. Just weeks later, in the early hours of 20 August, the dredger was in a collision with the Thames pleasure boat *Marchioness,* resulting in the loss of fifty-one lives. *Bowbelle* herself was lost seven years later. Subsequent investigations led to the creation of a dedicated search and rescue resource, London Coastguard, that co-ordinates RNLI, fire brigade, PLA and police craft. The patrol boats of the Thames river police are based at Wapping.

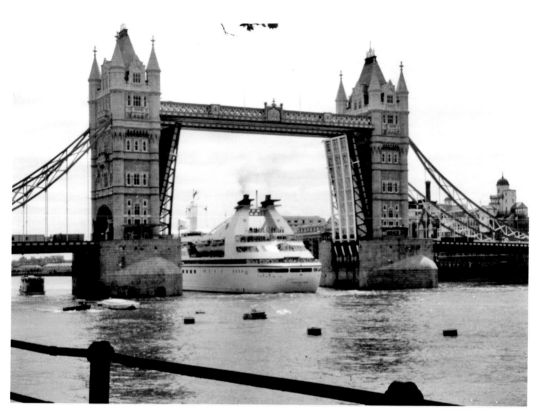

When Tower Bridge Opens

A rare sight nowadays is the raising of the giant bascules of Tower Bridge. This event is usually reserved for the summer season when cruise ships and the occasional excursion vessel enter and leave the Upper Pool. Leisure and pleasure very much prevail in this part of the river, as represented by an attractive fountain entitled 'Girl with a Dolphin', positioned close to the bridge that has welcomed shipping into London since 1894.

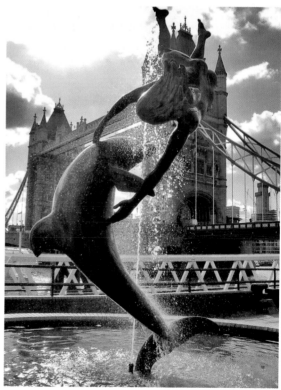

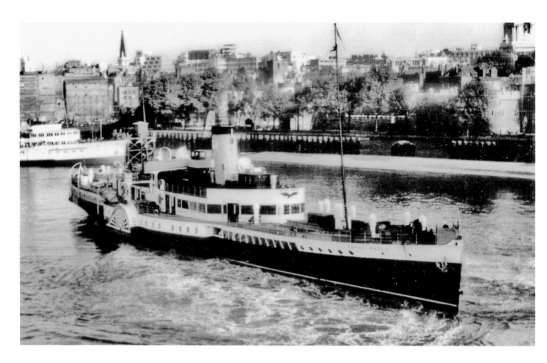

Paddle Steamers Live On

The popular 1,538-grt paddle steamer *Royal Eagle*, built in 1932 for the General Steam Navigation Company, regularly plied from Tower Pier to Southend, Margate, Ramsgate and Felixstowe until her withdrawal in 1950. She could carry almost 2,000 passengers. Happily, those days have been revived by the annual appearance in the Thames by *Waverley*, 1947/693 grt, now the world's largest paddle steamer. Saved from extinction by the Paddle Steamer Preservation Society, she was completely refurbished thanks to grants awarded by the National Lottery Fund.

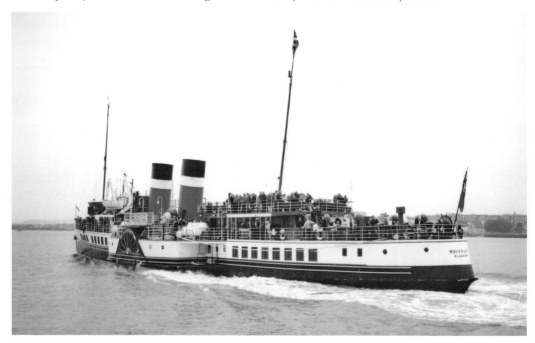

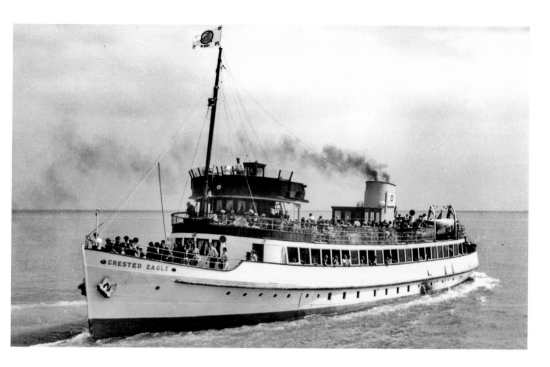

Thames Motor Excursion Ships

The little motorship *Crested Eagle*, 248 grt, the second vessel to bear the name, was built in 1938 for excursion work from Scarborough. Purchased by General Steam in 1948, she ran downriver trips from Tower Pier, including cruises round the Royal Docks in conjunction with the PLA. The only full-time excursion ship currently on the Thames is the Gravesend-based *Princess Pocahontas*, purchased in 1989 from Germany.

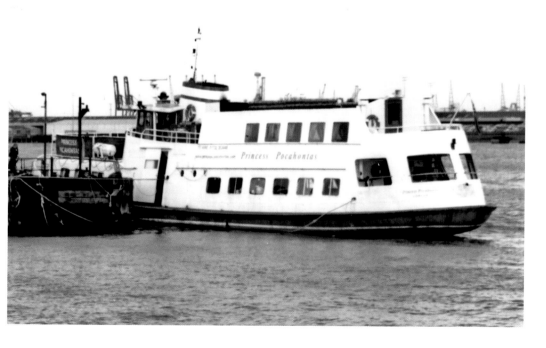

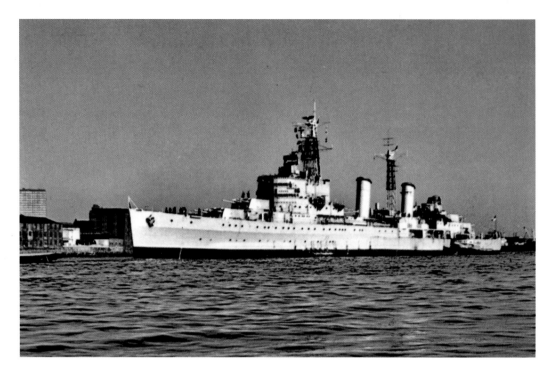

HMS *Belfast* Comes to Town

Under bright blue skies the Second World War cruiser HMS *Belfast* is towed into London to start her role as a static tourist attraction. Moored in the Upper Pool, she has also acted as an upriver berth, mainly for passenger vessels. The 4,871-grt *Litva*, built for the former USSR in 1960, was one of her first visitors.

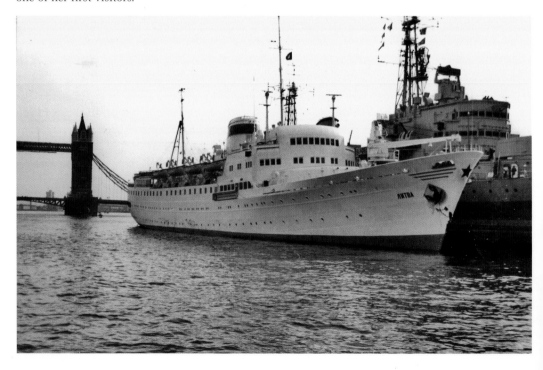

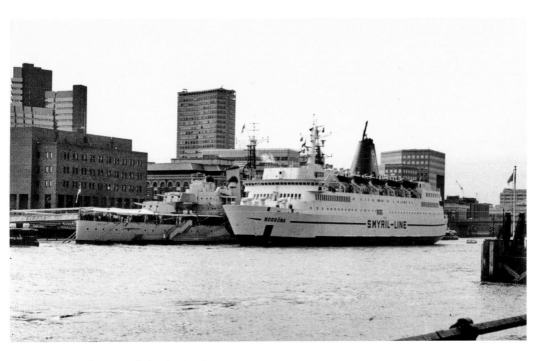

More Cruise Vessels in the Pool

Tied up alongside HMS *Belfast*, the Faroe Islands ferry *Norrona*, 1973/11,995 grt, made a rare visit in 1997 amid a round-Britain cruise. Silverseas' upmarket cruise ship *Silver Cloud*, 1994/16,927 grt, has frequently berthed since being pictured as a brand-new ship, dressed overall, in September 1994. She is due to visit the Pool during the 2012 Olympics, complementing her larger fleetmate *Silver Whisper,* expected at Greenwich.

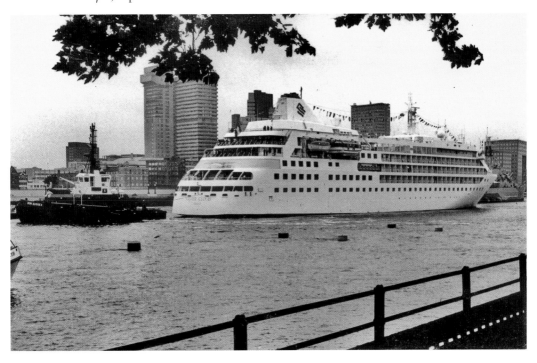

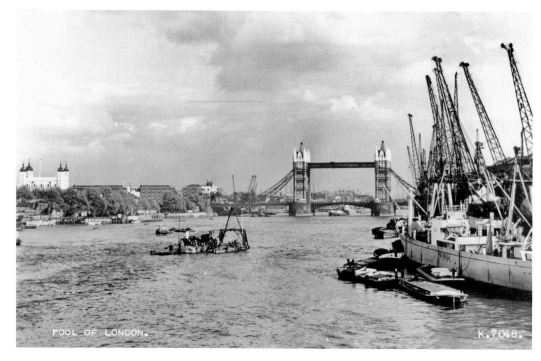

POOL OF LONDON. K.7048.

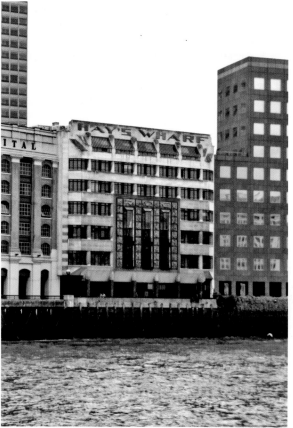

London's Larder
The Upper Pool, looking downstream from London Bridge, during the 1950s. Note the Danish cargo ship on the right, berthed at Hay's Wharf. Vessels from Denmark and the Baltic would bring in bacon, butter and other dairy products to the wharf that consequently became known as 'London's Larder'. Behind its frontage the wharf contained an enclosed dock and since its closure this has been converted into Hay's Galleria, an impressive mall featuring smart shops and eating places.

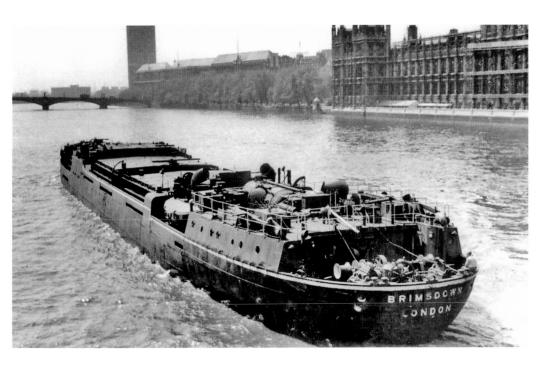

From Coal to Tourism

Around half a century ago as many as 150 colliers were bringing in coal to London's power stations and gasworks. Of these, forty were flat-iron colliers, so called because by lowering their mast and funnel they could pass under many Thames bridges as far upriver as Wandsworth. *Brimsdown*, 1951/1,837 grt, was owned by the Central Electricity Generating Board. Today only two downriver power stations exist within the Port of London, at Littlebrook and Tilbury, and the flat-irons are memories of the past. Instead, London's river is heavily populated by river cruisers as tourism becomes ever more important for its future success.

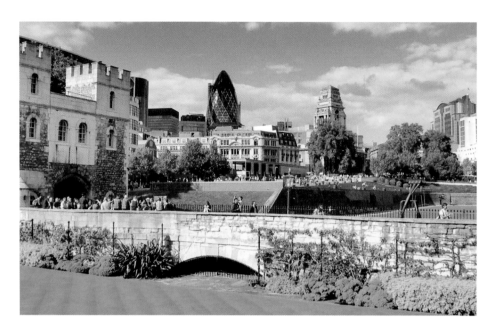

Back to the Future
In this view towards Tower Hill, the skyline, overlooking the Pool of London, still contains the PLA's former headquarters at Trinity Square. In contrast, to the left, is the futuristic 190-metre-tall 'Gherkin' building, constructed on the site of the Baltic Exchange, once the global marketplace for ship sales and shipping information.

Acknowledgments

For the compilation of this book I was able to call upon my own collection of photographs and facts and figures to which I personally added a number of extra images for inclusion within its pages. Over a period of twelve years I wrote a column for the Port of London Authority's in-house magazine *Port of London*, and having faithfully stored away every issue, I was able to revisit these for invaluable information. I am, however, greatly indebted to the following people without whose help this book would not have been completed: Duncan MacKenzie, who sought out several black and white photographs for me, Martin Garside of the Port of London Authority for supplying port maps, Campbell McCutcheon at Amberley Publishing for providing old images and maps, whilst colour images of the following ships are credited to Don Smith/Pictureships.com: *Doctor Lykes, Nadeshda Krupskaya, Kano Palm, Africa Palm, Clan Matheson, Hellenic Glory, Inowroclaw, Grande Nigeria* and *Han Chuan.* Finally, but by no means least, I thank my daughter Rebecca, whose hand is much steadier than mine, for shooting the majority of the recent digital images.